BASICS
FASHION DESIGN

CW00351051

Fashion Styling

Second Edition

BLOOMSBURY VISUAL ARTS
LONDON • NEW YORK • OXFORD • NEW DELHI • SYDNEY

BLOOMSBURY VISUAL ARTS
Bloomsbury Publishing Plc
50 Bedford Square, London, WC1B 3DP, UK
1385 Broadway, New York, NY 10018, USA
29 Earlsfort Terrace, Dublin 2, Ireland

BLOOMSBURY, BLOOMSBURY VISUAL ARTS and the Diana logo are
trademarks of Bloomsbury Publishing Plc

First published in Great Britain by AVA Publishing SA 2011
This edition published by Bloomsbury Visual Arts 2022

Copyright © Jacqueline McAssey and Sophie Benson, 2022

Jacqueline McAssey and Sophie Benson have asserted their rights under the Copyright,
Designs and Patents Act, 1988, to be identified as Authors of this work.

Cover image: Fashion Week Spring/Summer 2020, Madrid, Spain.
(© Pablo Cuadra/Getty Images)

All rights reserved. No part of this publication may be reproduced or transmitted in any
form or by any means, electronic or mechanical, including photocopying, recording, or any
information storage or retrieval system, without prior permission in writing from the publishers.

Bloomsbury Publishing Plc does not have any control over, or responsibility for, any third-party
websites referred to or in this book. All internet addresses given in this book were correct at the
time of going to press. The author and publisher regret any inconvenience caused if addresses have
changed or sites have ceased to exist, but can accept no responsibility for any such changes.

A catalogue record for this book is available from the British Library.

A catalog record for this book is available from the Library of Congress.

ISBN: PB: 978-1-3500-7410-1
 ePDF: 978-1-3500-7411-8
 eBook: 978-1-3502-4184-8

Typeset by Integra Software Services Pvt. Ltd.
Printed and bound in India

To find out more about our authors and books visit www.bloomsbury.com
and sign up for our newsletters.

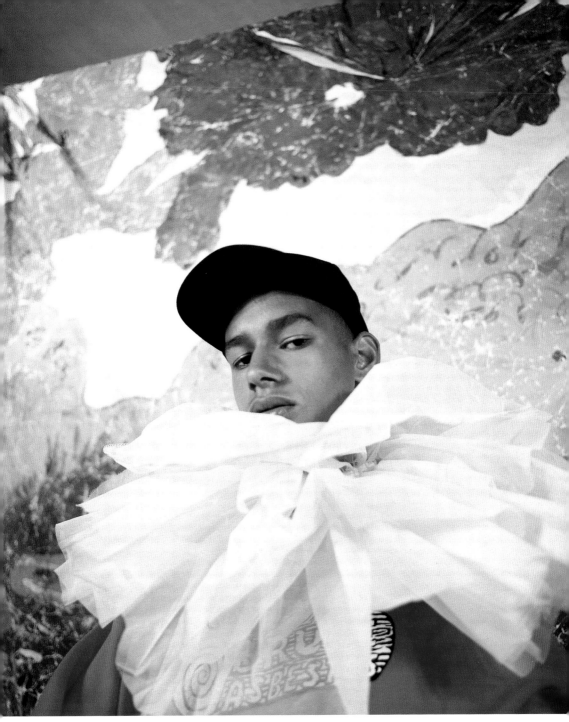

Figure 0.1 Menswear editorial showcasing clothes by designer Bruce Asbestos.
Photographer: Lucie Armstrong. Styling: Helen McGuckin.

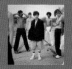

5

The Photoshoot in Production 117

6

Becoming a Stylist 139

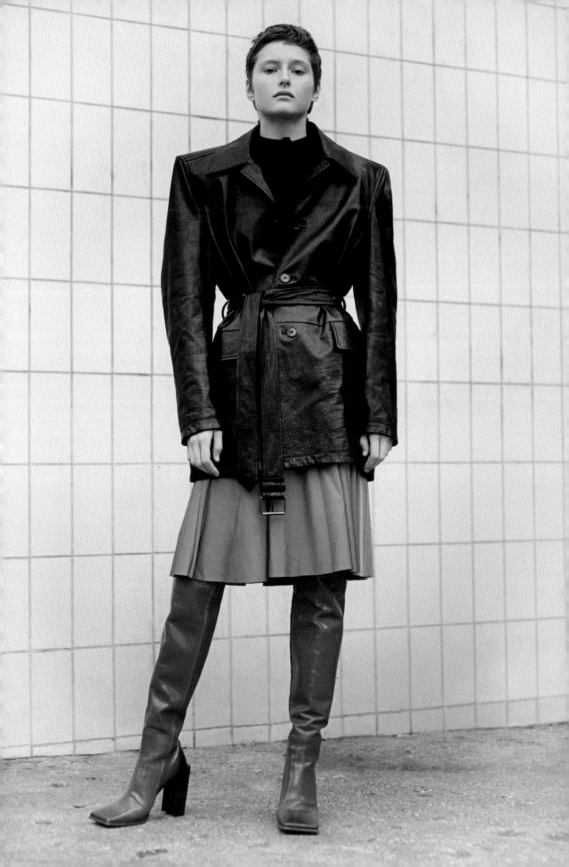

1

The Fashion Stylist

Introduction

Put simply, a fashion stylist is responsible for choosing the look and clothing, and often much more, to communicate a fashion idea, trend or theme, or to advertise a fashion product. This book has been written for those who are interested in the process of fashion image-making and what the job entails. It will inform you about how and why the stylist has become an integral part of fashion image-making in publications, both online and in print, advertising campaigns and more recently as a consultant to fashion designers and brands.

You will also learn what it means, for example, to style for e-commerce, a still-life image or a fashion show and what types of skills these different fields require. Personal styling is explained in its various guises, from one-to-one styling in retail outlets to the styling of musicians and celebrities. Additionally, it will describe the day-to-day life of a stylist, which should help you to identify if this is the right career choice for you.

Figure 1.1 (facing page) **Fashion editorial for CR Fashion Book.** Photography: Andrew Vowles. Styling: Ben Perreira.

This book contains visual examples of inspirational styling, created not only by professionals but also undergraduates; proving that even on a limited budget, with imagination and drive, it is still possible to create beautiful and relevant work.

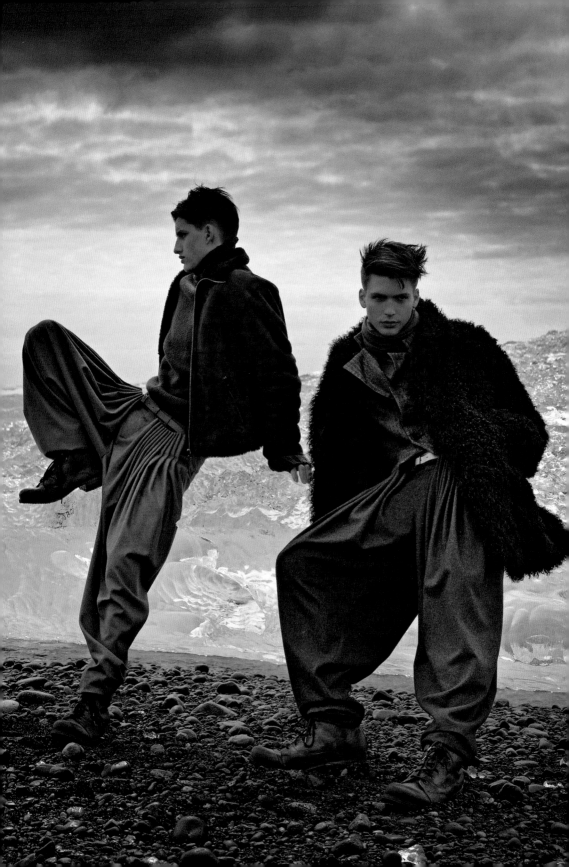

The Fashion Stylist

What is fashion styling?

Essentially, styling is a way of assembling clothing and accessories, to exhibit them in their most desirable or attractive way in order to sell them. This could include, for example, choosing accessories (belt, shoes and jewellery) to coordinate with and complement a dress. Fashion clothing can be styled alone or as a group of products (showing a range of colours), with or without a model. The styling process involves selecting and experimenting with many alternative garments to establish the perfect composition.

'I wanted to mix designer things with "found" things, and used to go to places like John Lewis' schoolboys' department to get a very eclectic mix.'

Melanie Ward

The origins of styling

The first stylists were fashion editors who worked exclusively for fashion magazines. Editors did in fact 'edit' the clothing and fashion pages, and they chose the designers to be featured in the magazine. Under the initial direction of the fashion editor the relationship that really mattered during the shoot was that of the photographer and model. Indeed, during the 1960s it was common for models to do their own make-up and hair and bring their own accessories to a shoot, forgoing the need for a third person. Then, during the 1980s the first freelance stylists appeared, working for new style magazines such as *The Face* and *i-D*. As these magazines did not have permanent fashion staff, freelance stylists could apply their inventive fashion ideas across a number of publications and clients. The stylist became an integral part of fashion editorial; a key contributor to the image-making process, who wasn't tied to one magazine or one point of view.

Ray Petri (1948–1989)

Ray Petri, thought by many to be the first stylist, was known in the 1980s for his 'Buffalo' style; a ground-breaking mix of urban uniform, ethnic dress, sportswear and high-end fashion. His use of real people instead of models (including Black and mixed-race men) in fashion shoots was, at the time, new and exciting. Petri contributed to *The Face* magazine and worked with designers Jean Paul Gaultier and Giorgio Armani. The creative collective he was part of was also named Buffalo and in the book of the same name, GQ editor Dylan Jones stated that even twenty years after Petri's death, 'Harder than the rest; in the age of the stylist, Ray Petri is still king.'

Figure 1.2 Muted menswear is shot against a dramatic landscape in this fashion editorial for *V Man*. Photography: Will Davidson. Styling: Mattias Karlsson.

Roles in styling

Stylists work in fashion editorial styling (magazines, in print or online); commercial fashion styling (advertising and e-commerce); in fashion shows and events; and as personal stylists for individual clients. The stylist's moniker also varies: they may be known as wardrobe stylists; on a publication such as a magazine or newspaper they are called fashion editors and assistants, and in fashion stores they can be referred to as personal shoppers.

Aside from the practical nature of the subject, styling is very much the opinion of the stylist, who imparts their often intuitive view on fashion. Even as a new stylist you are not judged on your practical skills alone; your own ideas, vision and taste are evident in each piece of work you produce.

Challenging perceptions

Styling can also challenge perceptions of fashion and style to move clothing in a new direction, and pieces can be put together in a way not originally intended by the designer. Fashion history is littered with these examples, which now seem commonplace: underwear worn as outerwear; women in men's formal attire; sports apparel placed in a fashion environment. Whether carefully coordinated or artfully juxtaposed, both approaches have their place in fashion styling.

Figure 1.3 **Fashion turned on its head.**
Photography: Marcus Palmqvist. Styling: Ellen Af Geijerstam.

Figure 1.4 **'Bricks and Bones', a menswear editorial for** *BITE* **magazine.** Photography: Lucie Armstrong. Styling: Sophie Benson.

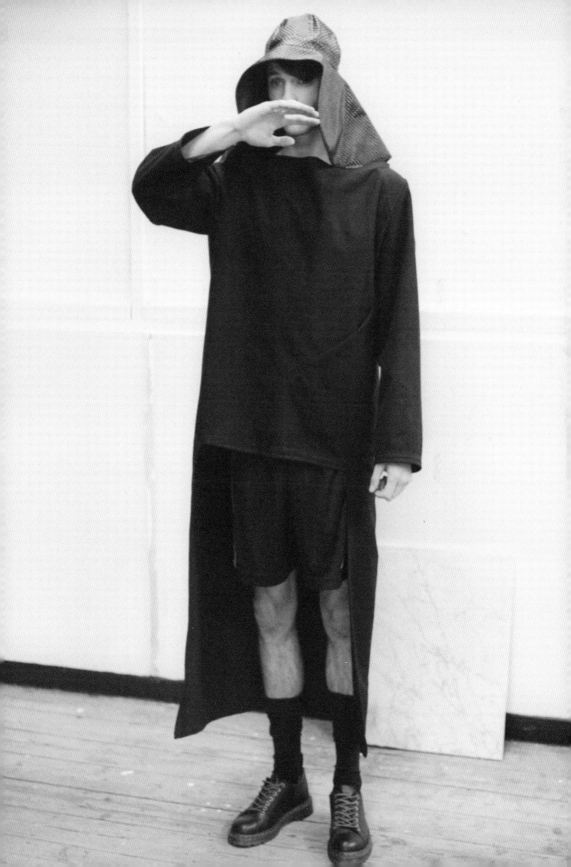

Aspects of the job

The nature of a stylist's job is very much dependent on the specific field in which they work. Some stylists will stick to one field throughout their career whilst others will move easily between the various forms of styling; some will work permanently for one magazine, company or studio, others work in a freelance capacity or may be represented by an agency. The stylist's overall input to a project can also vary considerably. A stylist working for a publication may have a responsibility to create something in line with a particular aesthetic and as such will have more control of a project, whereas a stylist working on an advertising campaign is likely to be part of a large team and will defer to the client and the brief. These different working methods are further explained in Chapter 3.

Along with the photographer, the stylist is a key member of the photoshoot crew and the planning and production of the shoot is often well within the stylist's remit. They may source appropriate locations, attend model castings and direct the shoot brief, as well as look after the model on the shoot day itself and generally ensure that proceedings go smoothly. What follows is a basic explanation of what is expected of a stylist working in the fashion industry today.

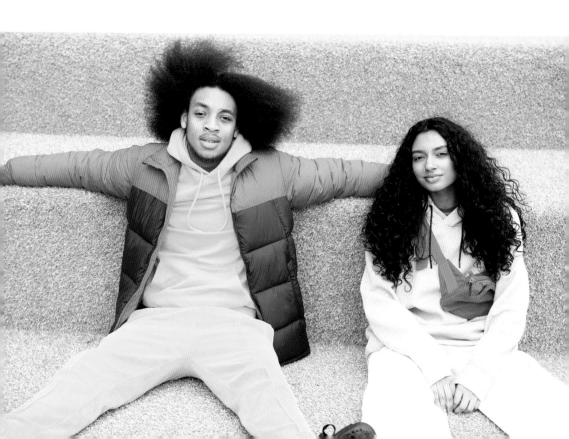

Influential stylists

Akeem Smith, Alex White, Alice Goddard, Alistair Kimm, Alistair Mackie, Anaita Shroff Adajania, Anna Dello Russo, Anya Ziourova, Barry Kamen, Benjamin Kirchhoff, Camille Bidault-Waddington, Carine Roitfeld, Carlyne Cerf de Dudzeele, Caroline Baker, Charlotte Stockdale, Clifford Jago, Diana Vreeland, Edward Enninful, Emmanual Alt, Ewelina Gralak, George Cortina, Grace Coddington, Ibrahim Kamara, Isabella Blow, Jacob K, Jameela Elfaki, Jane How, Jason Rembert, Jodie Barnes, Joe Mckenna, Judy Blame, Julia Sarr-Jamois, June Ambrose, Kate Phelan, Katie Grand, Katie Shillingford, Katy England, Law Roach, Leaf Greener, Lotta Volkova, Manuela Pavesi, Marie Chaix, Marni Senofonte, Max Clarke, Max Pearmain, Mel Ottenberg, Melanie Ward, Misa Hylton, Nicola Formichetti, Olivier Rizzo, Panos Yiapanis, Patricia Field, Patti Wilson, Penny Martin, Poppy Cain, Rachel Zoe, Ray Petri, Robbie Spencer, Simon Foxton, Suzanne Koller, Ty Hunter, Vanessa Reid, Venetia Scott.

Edward Enninful

Scouted at 16, Enninful became a model, an assistant stylist and the fashion director of *i-D* magazine, all by the age of eighteen. Enninful's powerful yet graceful storytelling influenced the pages of international magazines such as *W*, *Vogue* Italia and American *Vogue*. As the first Black Editor-in-Chief of British *Vogue*, he continues to champion diversity through a critical fashion lens. In 2020, Condé Nast appointed him as editorial director of the company's European titles.

Figure 1.5 **A bright and bold commercial shoot.** Photography and styling: We Are, via Getty Images.

'Anyone who knows me knows that the message of diversity is quite literally part of my DNA.'

Edward Enninful

Fashion research

As a fashion stylist you are expected to keep up with everything fashion-related, including determining trends in fashion. Editorial stylists view the seasonal collections that are presented at the fashion weeks such as New York, London, Milan and Paris. Shows are often live-streamed or photographs of the looks can be found online after the event. They will analyse the collections, recording details such as key silhouettes, colours, prints and textures, and use this information to determine the key clothing trends they think will inspire their readers. Trend information is translated differently from publication to publication into fashion stories. When developing the story idea, the stylist needs to take into account the content and tone of the story, the model, type of shoot location and price of clothing according to the type of publication and its readership.

Stylists working on commercial projects should have a good awareness of the brand and the consumer. An advertising job will usually have a strict brief so a good commercial stylist will be able to follow it to the letter. Once the fashion story or advertising brief has been discussed and developed by the creative team, it is the stylist's job to work out how to achieve it.

In addition, stylists should be undertaking other research methods to inform their work; this could be anything from visiting art exhibitions and looking at street style imagery online to travelling and exploring other cities and cultures. See Chapter 2 for more on research.

Sourcing

Stylists are responsible for sourcing the clothes, accessories and often the props for a shoot. This mainly involves contacting the PR agencies and clothing brands and 'calling in' clothes for specific shoot dates and times. The clothing may be viewed online, in designers' lookbooks or by visiting PR showrooms after fashion week. It is often a competitive business: there may be only a few samples of any one style; if a piece isn't available the stylist may receive an alternative choice (or nothing!).

Stylists will also source vintage or period clothing from specialist outlets or collectors, or access historical clothing from costumiers. Stylists often make it their business to find up-and-coming designers, which gives them access to new and exciting fashion. There are no rules on how materials are sourced; they only have to be appropriate to the project.

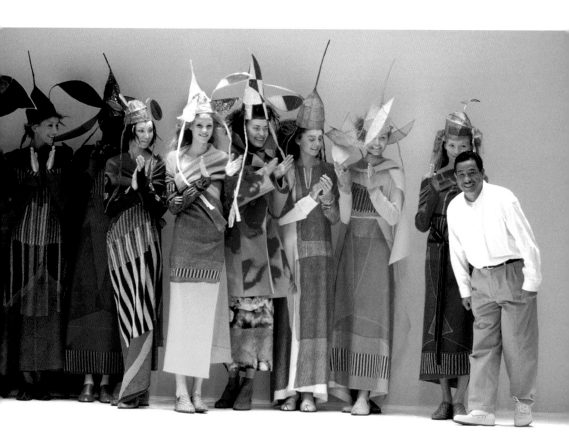

Figure 1.6 Issey Miyake AW97. Conducting research is important for all stylists, as is being able to critically analyse the seasonal collections, past and present. Photography: Daniel Simon, via Getty Images.

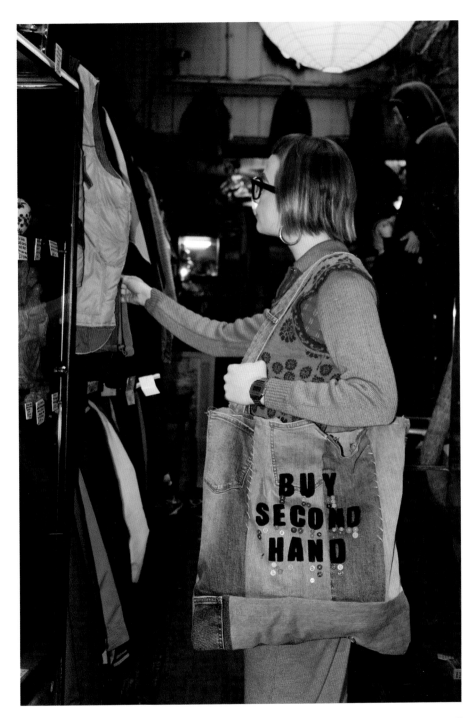

Figure 1.7 **Second-hand is a sustainable way to source a variety of garments, from rare one-offs to vintage designer pieces.** Photography and styling: Thalia Traynor.

Models

Liaising with model agencies is an important part of a stylist's job. The stylist and the photographer will look at the models available in different agencies, shortlist a number who may be right for the shoot, and the stylist will then check availability. The magazine or client normally has the final approval regarding the model, who is central to any editorial or commercial story.

Figure 1.8 **A typical agency shot shows the model in a studio setting looking natural.** Photography and styling: Luis Alvarez, via Getty Images.

Clothing

From the moment clothes are in your possession the designer, PR or retailer expects you to look after them. This means protecting clothes both in storage and during transit to shoots; ensuring that they are not soiled with make-up, and that they don't go missing from a set – essentially, returning them in the same condition as they came. Any clothing used in a shoot must be thoroughly documented with the designer or brand name, description and price. This is vital for editorial styling because readers need to know the cost and stockist information for any featured clothing.

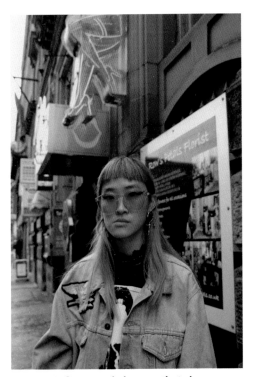

Figure 1.9 **Street style images that show more individuality and personality are becoming increasingly popular in model portfolios.** Photography: Martha Weaver.

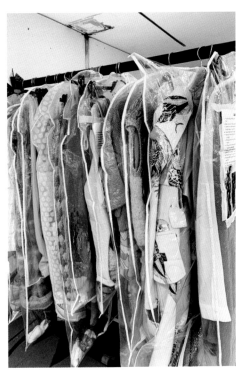

Figure 1.10 **Example of a fashion rail, with each garment carefully stored in a protective bag.** Photography: Tia Millington.

Your portfolio

Building and maintaining an up-to-date portfolio is essential for gaining more styling work; it should contain the very best examples of your work. When a photoshoot ends and the editing or retouching has been done the photographer will normally supply the stylist with final images for their portfolio. For editorial work, magazine tears can be presented in a portfolio in addition to photographs.

Figure 1.11 **A series of portfolio spreads showcasing a range of styling work by Indie Kelly.**

Freelance

Working as a freelance stylist can be challenging, with the risk of irregular work, job cancellations, no fixed income and no holiday or sick pay. On the plus side, working in a freelance capacity offers the opportunity to meet new people, to work on different projects day to day and to travel more. Good stylists may want to be represented by an agent who will find work on their behalf and send out their portfolio to prospective clients. For every job the agent procures they will take a portion of the stylist's fee.

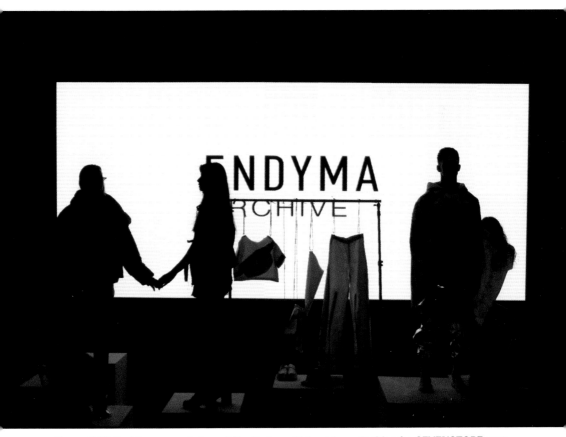

Figure 1.12 **Fashion presentation of the Endyma Helmut Lang Archive for SEVENSTORE.com**
Photography: Heather Smith.

Administration

Styling involves a great deal of paper-work: keeping a record of clothes that have been borrowed and proof of how and when the clothes were dispatched, whether by courier or by hand. For free-lance stylists the paperwork increases dramatically; they also have to provide evidence of expenditure (such as receipts from styling jobs) and invoices for tax reasons.

Lifestyle

What people don't often realize is just how physically demanding the stylist's job can be. It requires lots of energy to pull heavy bags of clothes, rails or steamers from car to studio and back again. The stylist is present during the set-up of a shoot and is always the last one to leave, making sure the location has been left immaculately clean. Such a demanding schedule can affect one's home and social life.

Consultancy

Today's stylists are taking on increasingly sophisticated roles. Some have close relationships with fashion designers, playing a part in influencing the design process and presentation of collections. As creative directors they use their unique research skills and knowledge to inspire new fashion collections and direct fashion shows. The level of experience required for consultancy is generally attained over a number of years of working at a profes-sional level.

Figure 1.13 **Fashion editorial for *Harper's Bazaar* magazine.** Photography: Jonas Bresnan. Styling: Vanessa Coyle.

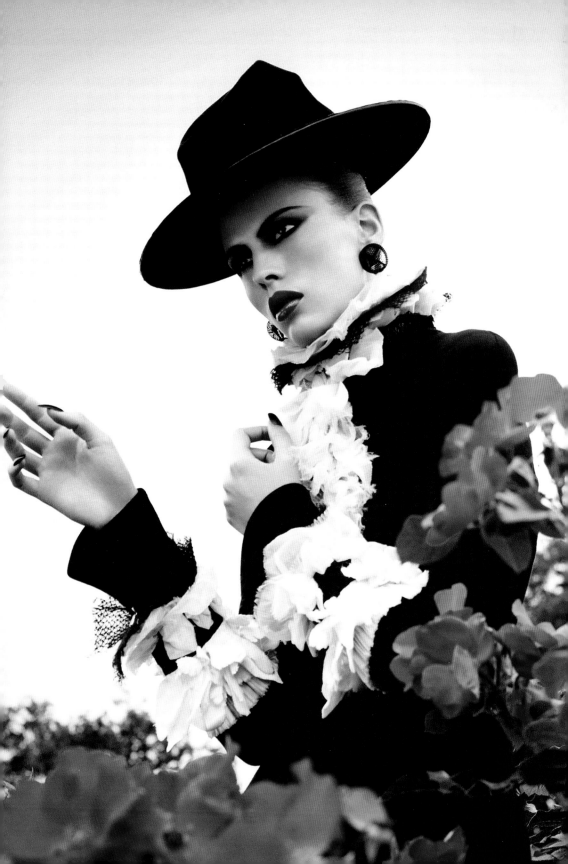

Figure 1.14 Behind the scenes at a fashion shoot for *The Guardian Weekend* magazine. Photography: Katie Naunton-Morgan.

A career in fashion styling

The traditional route of a fashion stylist was through journalism, with the fashion editor reporting on trends and creating fashion stories using words and visuals. However, there are now many established stylists who have entered the profession by studying fashion design and other creative disciplines; there are some who have not studied fashion at all. There are no hard and fast rules to beginning your styling career. There are benefits in both assisting a stylist and taking a course in styling, and in this section you will find arguments for both approaches. Transferable skills are also vital to the job of a stylist. Knowing how to organize your time, communicate with other people, work as part of a team and solve problems are all key to your professional and personal development.

'The editor of French Vogue, Carine Roitfeld, began life not as a wordsmith or manager but as a stylist.'

Tamsin Blanchard

Assisting a stylist

One route into styling is as an assistant, either for a professional stylist or at a publication or online platform. Learning the trade in this manner is an excellent way to be trained on the job, which will make you more independent. Assisting enables you to pick up practical skills and tips while you work and possibly receive payment for your endeavours. You will meet other creative people who may help with your career and there may be opportunities to travel. What is more, if you then decide to embark on a fashion or styling college course, you will almost certainly start as an assistant upon graduation.

First of all you will have to find someone to assist or someone who will give you experience and, as this is a competitive field, you may find this the most difficult part. You will be in competition with hundreds of college students who are also looking for styling experience, but who may have portfolios or examples of work they have already produced. If you are lucky enough to find a freelance stylist to assist, their work pattern is likely to be erratic and, essentially, you will work when they have work. They may have periods where they work constantly (including weekends or at night) and other times that are not so busy. As an assistant, payment for your work can be intermittent or non-existent. When you start out, you will usually be working not for the money but because you love what you do. This isn't an option for everyone and many are calling for all work experience to be paid in order to make it more accessible.

Your individual approach in implementing what you have learnt, your networking skills and, crucially, an element of luck, will all determine how successful you are in any creative industry. Networking is important but it doesn't mean speaking only to those you consider important. You can meet like-minded people anywhere: on social media, at exhibitions, fashion shows or parties. Be approachable. Listen to what people have to say about themselves and their work. Along with your talent you will be remembered and re-employed based on how you work with and treat other people.

Fashion education

Opting for a fashion education is for many the first step into the industry. Imagery is at the heart of most fashion courses, many of which offer fashion styling as part of the curriculum. Styling can be taught as a single subject or, to a lesser degree, as part of another field such as design or marketing. If you decide that studying a course in styling is the best route for you, then you must do your research. As well as covering subject-specific and key skills, most styling-related courses offer theoretical studies, such as marketing and business or cultural and contextual essays.

The benefits of a fashion education are evident. Higher education encourages you to undertake more in-depth research; to experiment and test ideas. In addition, you have a ready supply of specialist equipment and the space in which to carry out your work. More importantly, you have opportunities for cross-course collaborative projects with your peers, such as photography, design or illustration, for example. A good fashion course will also develop your employability skills by bringing in industry speakers and setting up industry-related projects, which give you insight into styling in the real world.

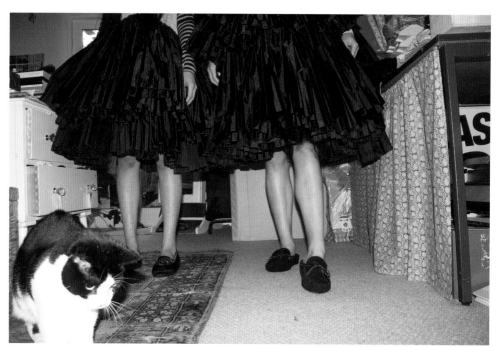

Figure 1.15 **Student fashion editorial featuring garments sourced from a graduate designer.**
Photography: Jessica Morris. Styling: Jessica Morris, Vicky Burns and Elizabeth Mitchell.

Figure 1.16 (facing page) **Student fashion editorial shot on location.** Photography and styling: Isobelle Binns.

Fashion styling

Studying styling as your major subject allows you to explore it in greater depth, learn practical techniques and even specialize in an area of styling, such as editorial or commercial.

Fashion design

Learning to design and make fashion garments and collections are valuable skills to a fashion stylist. Design graduates have knowledge of garment construction and how clothing fits the body; they can handle fabric well and have good sewing techniques. As a stylist, this means you will be able to style your own work for photoshoots.

Fashion journalism

If you want to write articles, features and general content, conduct interviews and work as a stylist, then this route is best for you. You will need very good writing skills to gain a place on this type of course.

Fashion communication, imaging, promotion and marketing

Course content varies significantly by institution but, generally speaking, these courses teach you how to visually and verbally communicate ideas through, for example, the production of a magazine concept or the promotion of a product or service. Usually these courses teach commercial and editorial styling alongside other subjects such as PR, graphic design, trend forecasting, visual merchandising and so on; they are good if you want an overview of fashion without having to focus on the design of clothing.

Photography

Gaining camera skills and learning about the technical aspects of photography, such as lighting, can be very advantageous if you want to be a fashion stylist. Taking a course that offers both styling and photography is helpful if you are unsure which route to take.

Costume

This is a more specialist route and would be a good choice if you have an interest in working within film, television or in the theatre. Costume courses will include the technical aspects of clothing construction, often incorporating traditional techniques such as corsetry and tailoring.

Photoshoot 2 - Contact Sheets (Edited Down) **Photoshoot 2 - Chosen Images / Edits**

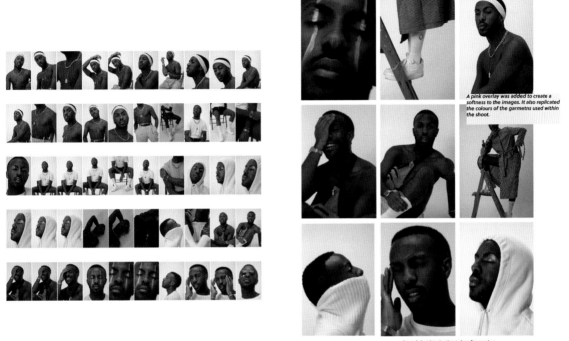

A pink overlay was added to create a softness to the images. It also replicated the colours of the garmetns used within the shoot.

Pose / shot inspiration taken from primary research. Use of different angles.

Figure 1.17 **A series of marketing images for a Glossier-inspired campaign.** Photography and styling: Martha Hollingsworth.

Interview

Helen McGuckin

Helen McGuckin is a freelance stylist. She has styled for *Hunger* magazine, *Wonderland* magazine and *Schön!* magazine.

What is the main difference between editorial and commercial styling?
The main difference between editorial and commercial styling is freedom and creativity. Editorial styling consists of a strong initial creative concept and, in my work, exaggeration of this idea pushed through fashion, accessories and sometimes even props worn on the body. With commercial styling you are working to a brief which will be beneficial to the client you are working with. This means you have to make sure the styling fully represents that brand/ brief and you are working in a different way to clearly promote a certain thing.

What is the stylist's role in planning an editorial shoot?
This depends on what type of stylist you are. As I get quite involved in ideas I do like to see an idea through to the end. It's very rare that I am just there to provide clothes for a shoot. I really like to immerse myself in the concept, building characters and using clothing and props to influence the narrative. The planning itself involves devising the initial idea, moodboarding, putting together the teams, casting models, keeping up with the new season collections and pulling the looks with the story in mind.

Where do you look for inspiration?
I find it quite difficult to purposefully 'look' for inspiration, it comes to me when I least expect it. I'm naturally inquisitive, I like talking to lots of people about life. I can be having a chat with someone about a range of topics and I'll think, 'This would make a great editorial.' I like to people-watch and see how we all live, dress and respond to each other. I love looking at photography that causes a reaction. Films, art gallery visits and lots of music helps too. I try very hard to not be directly inspired by fashion alone, and try to see other things and then relate it back to fashion in my own way.

How do you source clothes and what challenges might you face?
I always start with the designer collections, then I check with PR's designer lookbooks where I see the clothes in more detail. Next I try and find relevant vintage for the story to distinguish the looks from other stylists who may have used the same pieces. I might also make piece or add props into the looks to make them more interesting. It can be challenging if your favourite look doesn't fit or work in real life. There are also other factors to consider, such as checking if the model is vegan and won't wear leather or if they are allergic to latex for instance.

Figure 1.18 'Pit Stop', an editorial for *Schön!* magazine. Photography: Leanda Heler. Styling: Helen McGuckin.

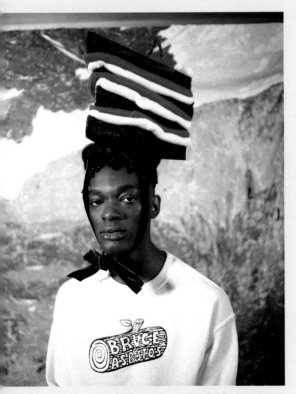

Figure 1.19 A menswear editorial for *King Kong* magazine. Photography: Lucie Armstrong. Styling: Helen McGuckin.

Who instigates the idea for an editorial shoot?

It differs each time. Often, an editorial shoot comes from myself having an idea or a need to produce something creative. I will pitch the concept and who the team is to a publication to see if this would work for their theme or aesthetic. On other occasions, a magazine may approach me to contribute to an issue, giving me details about their theme and I develop a concept around that.

How did you gain your experience?

I gained my experience through internships and assisting. I went to university and gained a BA Hons in Fashion Studies but I truly learnt everything about how to be able to work as a stylist by working with other stylists. I admired the stylists I assisted and it helped to see how the process came together from an idea and how that could be nurtured into a final piece of work.

Interview

Max Clark

Max Clark is Senior Fashion Editor of *i-D*. He has styled editorial shoots for British *Vogue*, *Fantastic Man* and *W* magazine, and has worked with brands such as Ralph Lauren, Supreme and Off White.

Can you explain how your career evolved from stylist to fashion editor?
After studying fashion at university I proceeded to assist Jodie Barnes. At the time he was Fashion Editor at *Arena HOMME+* and he then moved on to be Fashion Director at *Fantastic Man*. I worked for Jodie for three years until I went freelance. While I was assisting him I also managed to build up a good close network of friends who worked in the industry too. At the same time, *Arena HOMME+* changed editorship. Ashley Heath became Editorial Director with Max Pearmain as Editor. I'd already met both of them and Max was a massive support for me early on. He brought me in to meet Ashley who offered me a job after chatting for an hour in the kitchen at our Hanover Square offices. I stayed at *HOMME+* for four years before joining *i-D* in 2014.
There are quite distinct differences between working as a stylist and as a fashion editor. As a freelance stylist, you are representing yourself and running your own business. Essentially it's purely a creative role. There are times that you work within the aesthetic of other brands or designers but you are encouraged to voice your opinion and place your own aesthetic into what you're doing. There is a need to know how to market yourself and showcase your work, but you're really focusing on what you are doing.

As Senior Fashion Editor at *i-D* I have an input into so many different parts of the brand:

- Sales and working alongside our advertising department trying to sell our products to clients as well as maintaining existing relationships.

- PR, marketing and distribution; discussing where to promote what we have produced.

- Searching for and uncovering new talent to commission to work on their own stories within the magazine.

- Coming up with overarching themes and ideas for each issue and what talent to include.

- Representing *i-D* at international fashion weeks, and establishing relationships with PR, marketers and designers.

- Working alongside the art and design teams looking at layouts and edits for fashion stories.

It's important I have an eye on what brands are being covered editorially, making sure I have a good balance of the most relevant brands of the moment as well as the brands supporting the magazine. Being a fashion editor is a lot more balanced between focusing on the work you are producing as a stylist and representing a media brand.

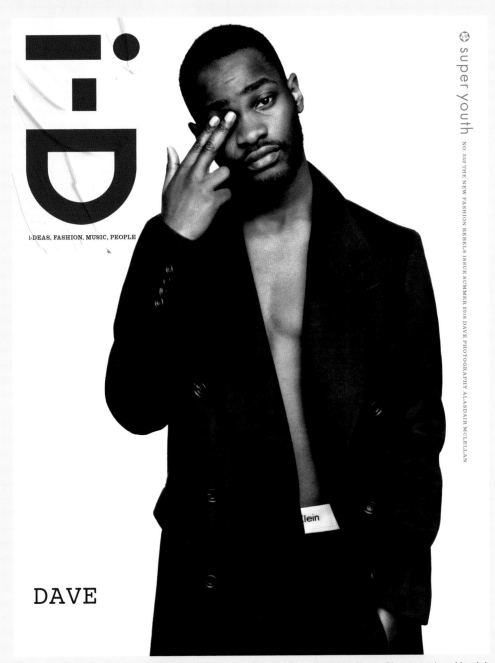

Figure 1.20 The cover of *i-D*'s Summer 2018 issue, featuring musician Dave. Photography: Alasdair McLellan. Styling: Max Clark.

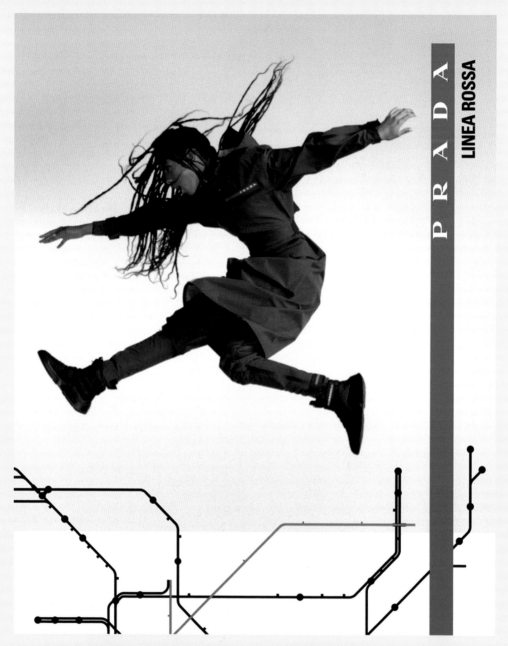

Figure 1.21 An image from the AW19 Prada Linea Rossa campaign. Photography: Nick Waplington. Styling: Max Clark.

How does the stylist's role differ between editorial and commercial work?

I always think the best work blends into one, whether it be for a magazine or advertisement, you can still tell it's a specific photographer or stylist's work. There is definitely more freedom to be experimental with editorial, you are representing your own vision. With a commercial job you have to work within the realms of the brands identity. But your role is really the same, helping create a strong character that people believe, aspire and buy into. You're creating something that speaks to either someone's reader or customer. It's important to believe in your instincts, have a strong opinion but back it up and articulate it clearly.

For commercial work, do you have a regular team that you collaborate with?

Yes, most people would agree that the key to building a good body of work is to establish a regular team to work with. Having a photographer, designer, hair stylist, make-up artist, even a producer that really shares your vision gives any project the strongest beginning. They are hard to find, you have to meet and experiment with different collaborators.

My Editor-in-Chief at *i-D* Alastair McKimm said to me when you're planning to work with someone, don't think you're going to do one shoot, think about doing five with this person. I thought this was a great piece of advice. It's important that you are sure that you share the same sensibilities and taste, but you can also elevate each other's ideas. It's horrible making mistakes in public.

You have to work on your relationships with other creatives within the industry. As a stylist you're not only thinking about clothing – anyone can style a rail of clothes – you're also there to create a spirit, a mood and a character. Clients book you for commercial work as they want you to bring a sense of that spirit to their brand or agency. It's such a collaborative job, you have to be open-minded. The best work is made when you're around people who share your way of thinking, it becomes almost telepathic.

How do aspiring stylists find new work? Is it important to have a physical portfolio or website and social platforms – or all?

Yes, it's important you have a platform for people to see your work. You should be selective about what you do, who you work with and who for. It's a long game and no rush, so there's no pressure to have a massive body of work to showcase early on.

Choose a medium that works for you. I personally still love print and printed portfolios, but other people understand how you can reach a lot of people instantly through social media. It's up to you and what you believe fits you.

Being within and around the industry as much as possible will help you gauge who the right people are for you. Assist and experiment and try to work out what your aesthetic is. Once you have a clear visual language and you're working on a strong level people will start to notice. Editors and Creative Directors can spot true talent and you will be discovered if you have it. The fashion industry is constantly searching for new talent, so make sure you are out there and ready to be discovered. It's important to build your network, you never know where one of your friends might find themselves working. Be nice to people on your way up, as you never know who you might meet on your way down.

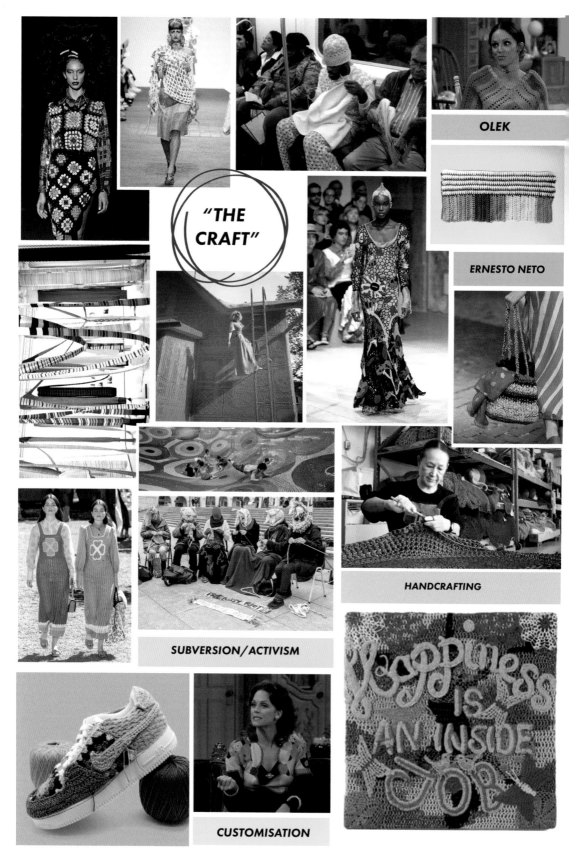

"THE CRAFT"

OLEK

ERNESTO NETO

HANDCRAFTING

SUBVERSION/ACTIVISM

CUSTOMISATION

Essential Research

2

Fashion awareness

Fashion research, with its close links to visual culture, encompasses many subjects; students should engage with a diverse range of research across a variety of topics. There are two kinds of research: primary and secondary. Primary material is original and doesn't already exist; using your own photography, drawings or conducting interviews first-hand all fall into this category. Secondary research is material that already exists, having been created by someone else; this includes printed and digital research obtained from books, the internet, magazines, newspapers, journals, reports and other printed material, such as photography, postcards, posters and so on. Undertaking both types of research will give you a broad picture of your subject and related areas, which will drive your work in innovative directions.

'Increasingly, the stylists are becoming the fashion designers' eyes and ears on the world; the secret weapon who pounds the streets in search of interesting reference material, be it the collar on a vintage dress or an obscure artist's monograph.'

Tamsin Blanchard

Figure 2.1 (facing page) **Visual research including catwalk, art and filmic references, by Sophie Benson.**

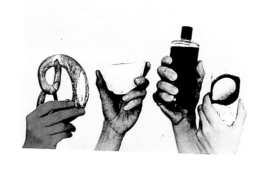

Becoming fashion aware

Fashion has a long and detailed history and it is expected of someone working in the industry, particularly in the fields of design and styling, to be aware at least of the major designers who have innovated and shaped what we wear. Stylists who are concerned with creating work that is innovative and original must know what has been produced previously. Also consider where fashion originated and how economic and social changes have affected the design and manufacture of fashion, such as the austere look of the Second World War, followed in 1947 by the extravagance of Christian Dior's New Look.

Becoming fashion aware demands that you research all aspects of the industry, from couture to the high street. Examine fashion advertising, fashion trend pages, online subcultures, street style, fashion articles and interviews, trade reports and trend journals to give you a rounded view of the subject.

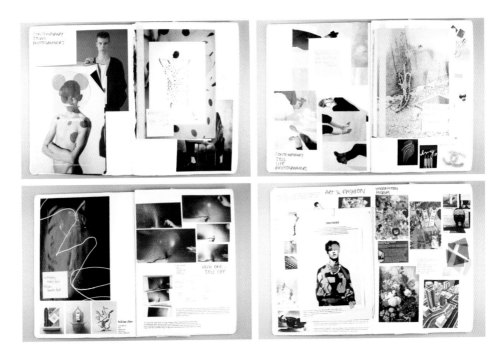

Figure 2.3 **Research sketchbook pages exploring fashion, artistic and still-life references, by Lauren Roberts.** Photography: Marc Provins.

Figure 2.2 (facing page) **A collection of art references by Clare Buckley.** Photography: Dave Schofield.

Simon Foxton

With a background in fashion design, Simon Foxton is a menswear stylist known for his humorous, street-influenced style of sportswear and tailoring. Fashion director for *Fantastic Man* and consultant fashion director for *i-D* he also contributes fashion stories to *Arena HOMME+*, *Vogue Homme* and *POP* magazine. Foxton collaborated with Nick Knight on the ground-breaking Levi's campaign, which featured real 'octogenarian ranchers' as models. His styling work was the focus of an exhibition at the Photographers' Gallery in 2009 entitled, 'When you're a boy'.

Style icons

There are many enduring images of stylish people who have epitomized a designer's vision or reflected the mood or feeling of a particular period: think of First Lady Jackie Kennedy in the famous pillbox hat by Oleg Cassini or Bianca Jagger marrying Mick in a Yves Saint Laurent white suit and veiled floppy hat. These style icons continue to be referenced by designers and stylists today. Examine what it means to have personal style and why iconic dress styles from the 1930s or 1960s are still popular today. See the box for a significant list of style icons, past and present, from the worlds of fashion, art, music and acting, to investigate as part of your fashion styling research.

Significant icons

Adrien Brody, Alain Delon, Andre Leon Talley, Andy Warhol, Anita Pallenberg, Anna Piaggi, Annie Lennox, Audrey Hepburn, Bianca Jagger, Billy Porter, Björk, Blondie, Bob Dylan, Bob Marley, Boy George, Brigitte Bardot, Bryan Ferry, Camille Bidault-Waddington (stylist), Cary Grant, Catherine Deneuve, Celine Dion, Charlotte Rampling, Cher, Chloë Sevigny, Coco Chanel, David Beckham, David Bowie, Diana Ross, Diana Vreeland (fashion editor), Diane Keaton, Edie Sedgwick, Elvis Presley, Ezra Miller, Farrah Fawcett, FKA Twigs, Françoise Hardy, Freddie Mercury, Frida Kahlo, Grace Jones, Grace Kelly, Héctor Bellerín, Humphrey Bogart, Ian Brown, Iris Apfel, Isabella Blow (stylist), Jackie Kennedy, Jaden Smith, James Bond, James Dean, Jane Birkin, Janelle Monáe, Jay-Z, Jean Michel Basquiat, Jean Shrimpton, Jim Morrison, Jimmy Hendrix, Joan Collins, Joan Crawford, Josephine Baker, Julie Christie, Kanye West, Karen O, Karl Lagerfeld, Kate Moss, Katharine Hepburn, Kim Kardashian, Lady Gaga, Lauren Hutton, Lou Reed, Lupita Nyong'o, Madonna, Malcolm McLaren, Maria Callas, Marianne Faithful, Marie Helvin, Marilyn Monroe Marlene Dietrich, Marvin Gaye, Mary-Kate and Ashley Olsen, Miley Cyrus, Nancy Cunard, Neneh Cherry, Paul Weller, Pharrell Williams, Prince, Prince Charles, Princess Diana, Quentin Crisp, Rihanna, Romy Schneider, Ru Paul, Rudolph Valentino, Serge Gainsbourg, Sid Vicious, Sophia Loren, Steve McQueen, Stevie Nicks, The Beatles, Tilda Swinton, Tom Ford, Vivienne Westwood, Wallis Simpson, Yayoi Kusama

Figure 2.4 **Fashion editorial for *10 Men*.** Photography: Will Davidson. Styling: Simon Foxton.

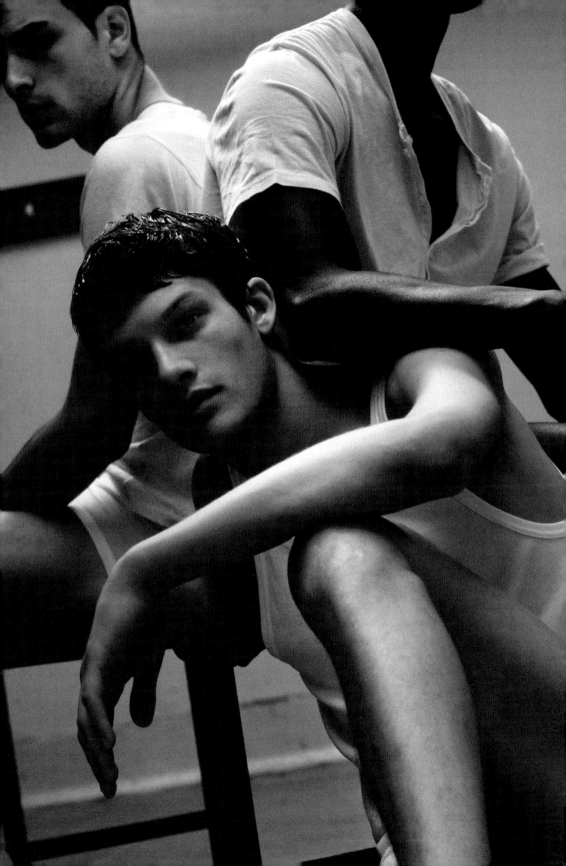

Street style

Using street style imagery as a research tool illustrates how dress differs around the world. Street style images can be found on dedicated websites, blogs, in magazines and on social media. As styling is about the assembly of clothing and accessories, these images illustrate how individual people interpret fashion by constructing and personalizing their dress. You can also take your own street photographs of people whose style you find interesting, which can be a useful source of primary research.

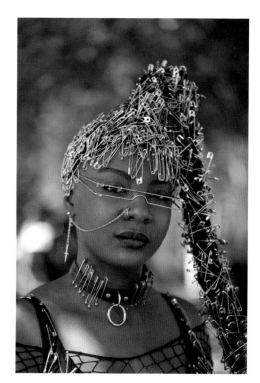

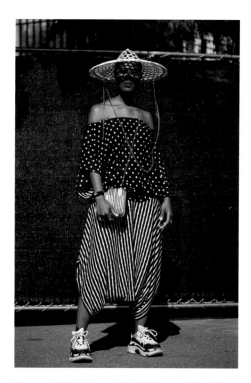

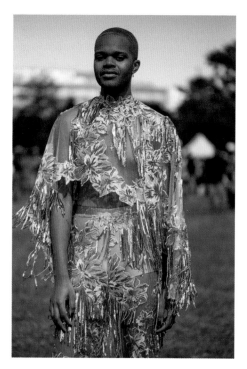

Figures 2.5 (bottom left), 2.6 (top right), 2.7 (bottom right), 2.8 (facing page) Selection of street style shots of Afropunk festival-goers. Photography: Matthew Sperzal (2.5–2.7) and Paras Griffin (2.8), all via Getty Images.

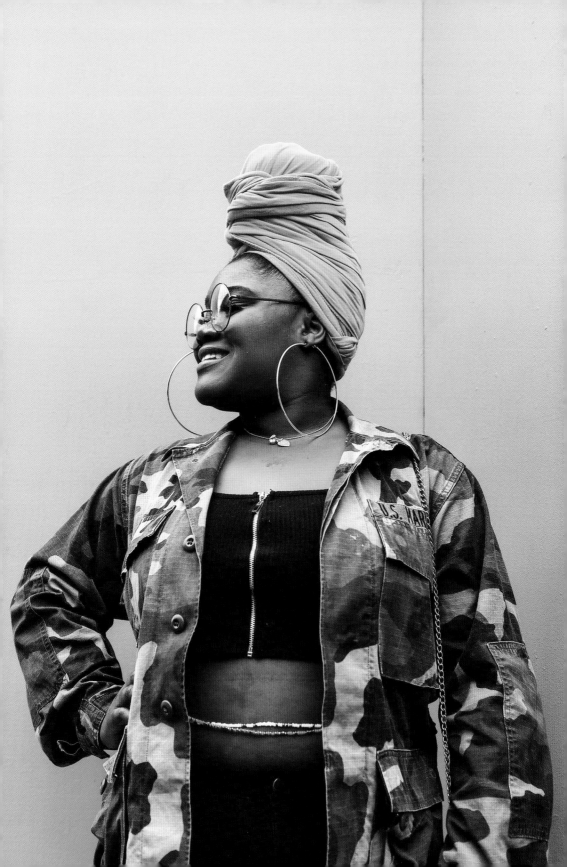

Fashion vocabulary

Fashion details are identified through the use of colour and silhouette, fabrics and patterns. It is important that stylists are able to identify and describe the many different styles of clothes and accessories as well as the different parts of a garment. Such identifying terms include type of fabric (cashmere, jersey, chiffon); print (devoré, digital, silk screen); sleeve (bishop, bell, raglan); collar (Peter Pan, button-down, spread); trouser (drainpipe, palazzo, culottes); accessory (turban, deerstalker or boater hat); or silhouette (empire line, trapeze, baby-doll). The correct use of these terms is vital in articulating what items you might require for a photoshoot or if you want to write about fashion.

A good knowledge of colour is equally important. The fashion cycle moves quickly; electric blue changes to royal blue, which moves on to cobalt, so using the right language in relation to colour is important for both stylists and fashion writers. Fashion knowledge will be accumulated through a mixture of research and experience but it will be assumed that as a stylist you possess a fundamental fashion vocabulary.

Figure 2.9 **Fashion test shoot based on a monochromatic theme.** Photography and styling: Zoë Victoiré.

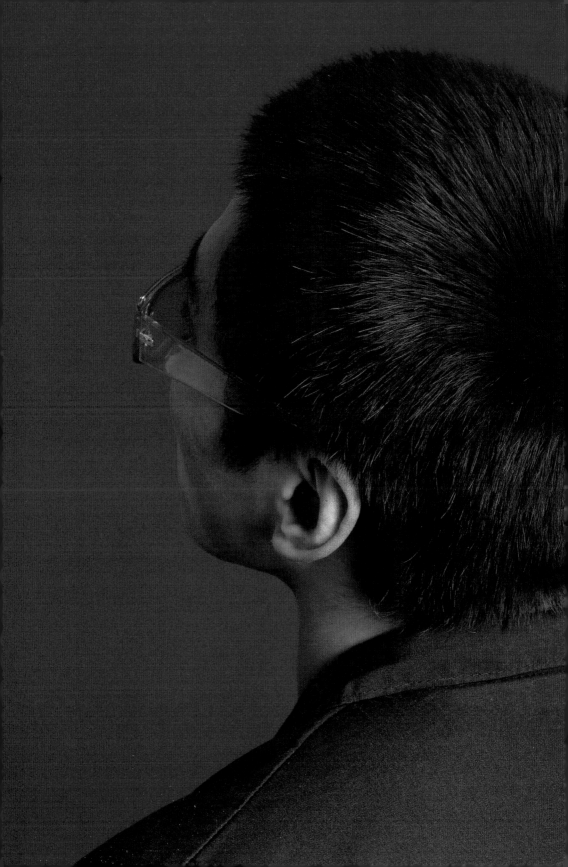

Context

Have you considered what wearing a smart suit or jeans and T-shirt says about you? Clothing has a language of its own, which can communicate social class, gender, wealth and occupation. Learning about the function of clothing, its meaning and status within society and its connection to social groups is an interesting aspect of fashion and style research. Many trends arise from the look of a particular social group, or subculture such as teddy boys and goths; groups that are identifiable by their style of dress, hair and make-up. Many modes of social dress styles have crossed over and are now recognizable within mainstream fashion. Consider denim clothing (jeans, shirts, jackets) for example: originally worn as functional workwear, it has been around for over a century and been adopted by various groups within that time such as cowboys, teen rebels in the 1950s and hippies in the 1970s. Black leather motorcycle jackets formed the staple uniform of the anti-establishment 'Hells Angels' gang. Signifying toughness and masculinity, this form of dress has now become an everyday style and wouldn't be out of place in a shoot in a fashion magazine.

Figure 2.10 **Blue jeans menswear editorial for *Wallpaper* magazine.** Photography: Scott Trindle. Styling: Sébastien Clivaz. Collages: Studio Boyo.

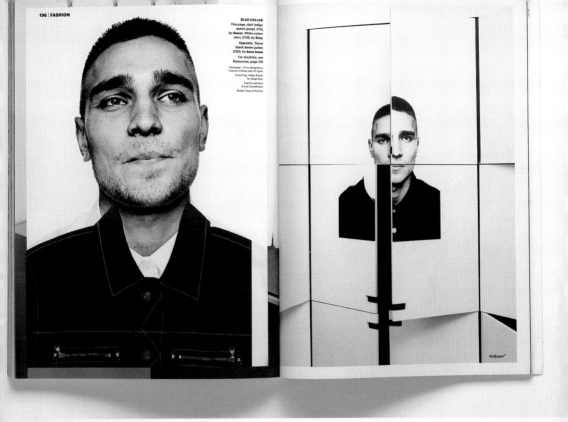

BLUE COLLAR
This page, dark indigo
denim jacket, £113,
by **Guess**. White cotton
shirt, £105, by **Sisty**

Opposite, 'Steve'
black denim jacket,
£150, by **Acne Jeans**

For stockists, see
Resources, page 296

Wallpaper* office designed by
Thomas Eriksson and Ulf Agner
Grooming: Halley Brisker
for Stage Door
Fashion assistant:
Ursula Geisselmann
Model: Texas at Premier

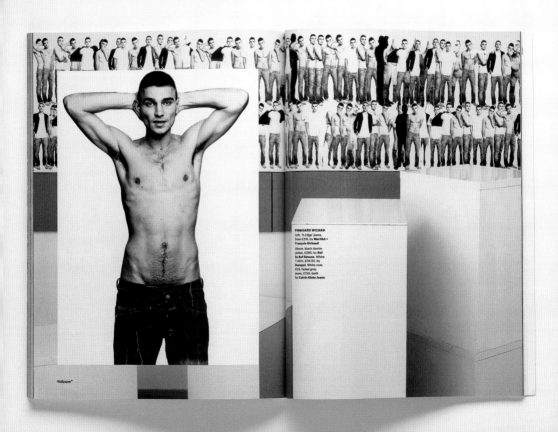

PINBOARD WIZARD
Left, 'X-Edge' jeans,
from £215, by **Marithé +
François Girbaud**
Above, black denim
jacket, £280, by **Raf
by Raf Simons**. White
T-shirt, £34.50, by
Sonapol. White vest,
£33; faded grey
jeans, £120, both
by **Calvin Klein Jeans**

Cultural appropriation

While cultures and subcultures have played a prominent role as a source of inspiration for fashion designers and image makers, it is important to understand the cultural significance and meaning that is attached to a particular item of dress. Cultural appropriation within fashion is when clothing or accessories are borrowed from a minority or disadvantaged community and used purely as fashion adornment.

The traditional Native American headdress, for example, became a staple of festival wear and festival-inspired shoots, and the original significance of the piece was forgotten. Native Americans objected to their traditional headdress, a symbol of strength and bravery which demonstrates that the wearer is a respected member of their tribe, being worn as an accessory.

Other examples include religious symbols and dress such as the hijab and crosses and hairstyles from Black culture like cornrows and dreadlocks.

Contextual studies are important for three reasons: first, to develop your ability to critically analyse the way in which images work and to get the most out of your own practice; secondly, to enable you to learn what has gone before you, what is happening currently and globally and how your work reflects this; and thirdly, to provide visual and intellectual stimulation that will feed into your work. They include any visual or literary material that will help you on this path, including art and design history, film, television, philosophy, literature and cultural theory, and the development of your own critical abilities through discussion and writing.

Critical analysis

It is important to have a good understanding of how images work and be able to articulate that effectively. For example, you need to understand how the use of a particular colour or texture will translate in a photograph or how things such as lighting, setting and a model's body language affect a photograph. What difference would it make if these things were even slightly different? It is useful to critique images other than your own so that you can develop these skills and use them to assess your own work. Eventually this will become an instinctive and invaluable part of your creative practice.

Context

Your work is about communicating a message through images; to do this effectively you will need a good knowledge of how it will be understood by others in different contexts. A broad understanding of research techniques is essential, such as using the library, making enquiries to experts in any field and searching the internet for relevant material.

Inspiration

You will stimulate your intellect and creativity by examining a variety of images and literature outside of your personal interests, material that you would not otherwise consume. It is important to keep exposing yourself to new and challenging material throughout your career, to ensure your work is both inspired and inspiring!

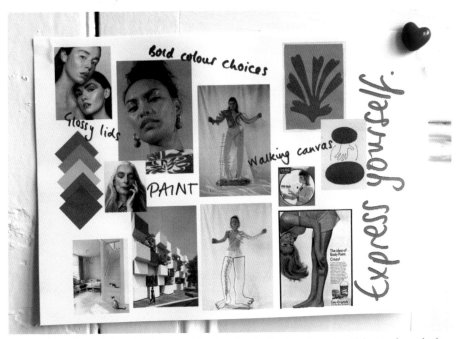

Figure 2.11 Moodboard drawing from architectural, artistic, beauty, advertising and musical references, by Lauren Roberts.

Fashion referencing

Fashion referencing is a term to describe all of the research elements a stylist brings together to inspire a styling project. Trends by their very nature are popular one season and out the next; as such, following their rise and fall is always associated with a stylist's work, particularly in editorial. It is understandable, therefore, that students will reference designer collections and fashion platforms in their creation of styling projects. However, it is incorrect to assume that all stylists slavishly follow the trends from season to season. Stylists subconsciously soak up ideas wherever they are and can be inspired by the most obvious or incongruent things. Inspiration can come from visual sources, such as architecture, popular culture, art or film; it can come from stories or philosophy, such as theories of beauty and aesthetics. References to an individual's upbringing and personal memories are often expressed through a stylist's work: finding connections, themes and developing styling ideas from a somewhat disparate collection of references is a creative and rewarding process.

Fashion references can be collated in several ways. Creating moodboards and sketchbooks are a common but useful way to archive your work and communicate your thoughts. Research can also be compiled and shared digitally or arranged beautifully on a wall in your workspace.

'Of course conventionally beautiful things are beautiful but everyone finds them beautiful and I find that boring. I want to be inspired by things that not everyone knows.'

Lotta Volkova

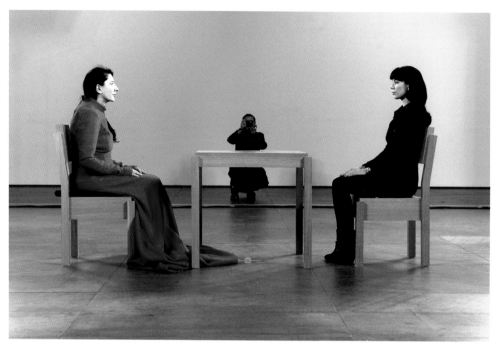

Figure 2.12 **Marina Abramovic wears red for her 'The Artist is Present' performance.** Photography: Andrew H. Walker, via Getty Images.

Fashion publications and platforms

A main source of research for most students, fashion publications and platforms are valuable in that they offer varied views on fashion. There are a great many established print magazines that are easily available, as well as independently published titles, which can be found in specialist bookshops or bought online. Archived examples of magazines such as *Vogue* can often be found in local or college libraries; these will support your historical knowledge of fashion editorial and fashion advertising. While most of the established print magazine have an online presence as well, an increasing amount exist solely online. Using these platforms for ideas and direction is commonplace but stylists should avoid regurgitating the ideas found within them. Analyse the content to gain an understanding of how they differ from title to title: who the audience is, the brands and designers that are featured and the price point of the clothes. Examine the fashion shoots to find out about the photographers and stylists, as well as the creatives behind the hair, make-up or set design; familiarize yourself with names and style of work, particularly if you want to work in editorial.

Being passionate about fashion editorial doesn't mean, however, that you should align yourself to this area alone. Move out of your comfort zone and source other publications. Next time you look for a new magazine or website, consider one that isn't fashion-related: a journal about horticulture, for example, or graphic design blog; or look at a different news site to develop your awareness of current affairs and opinions. Fashion is affected by global issues and events, such as ecological issues or new music and films; these can be researched quickly via news outlets, which are more up to date than traditional fashion publications that may have taken six months to produce.

Social media

In addition to fashion publications, social media platforms, such as Pinterest and Instagram, are a useful tool as you are able to browse images that have been posted by other users and collate them into digital pinboards or galleries. While being able to gather images in one place is convenient, you often view a single image from a set, losing the wider context such as narrative, who created it and where it first appeared. Relying entirely on these platforms for all of your research can be very limiting. It is best practice to look at a variety of sources.

Trend and forecasting resources

There are a number of subscriber and free-to-access trend platforms that allow you to decipher everything from what colours will be fashionable three years from now to why we buy certain products and the changes happening in retail. For example, an editorial stylist is able to revisit images from fashion weeks and identify the trends for the next season in order to gather inspiration for their shoots. Looks are often gathered into a series of trend stories by each platform, making forecasting easier. However, this is only one resource, and how you personally decode trend information varies according to how much freedom you have within your role.

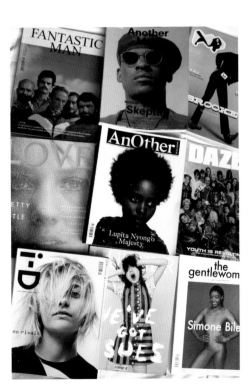

Figure 2.13 **A selection of magazines you will find useful for general fashion research.** Photography: Lauren Roberts.

Interview

Lily Charnock

Lily Charnock is Senior Culture and Trends Consultant at Join the Dots | InSites Consulting, a consumer insight agency.

What exactly does your job role entail?
Join the Dots | InSites Consulting is a global insights agency that works with brands to understand people. I'm part of the Culture and Trends team, and we specialize in taking emerging consumer trends and cultural insights and using them to generate foresight that is practically relevant and actionable for brands.

My role involves taking big themes that are impacting people today – such as sustainability, the trust crisis or the attention economy – and getting to the crux of how this is playing out, how it's changing people's needs and behaviours, and analysing what this means for brands. We use a range of methodologies and frameworks to do this, and we also partner with other researchers and agencies to deliver exciting and well-rounded projects.

My favourite projects are ones where we explore how contradictions and tensions in the human mind are combining with macro trends to create new needs and opportunities for brands to innovate. I have a background in social anthropology, so I'm always fascinated to explore the cultural and psychological factors influencing what people do!

How do you stay abreast of the latest culture and what's coming next? Where do you look, where do you visit, who do you talk to?
When exploring cultural shifts and subcultures, I think it's really important to head to the places where the first signs of change are visible. For themes around music, fashion and art for example, certain neighbourhoods, venues and consumer groups will be leading the pack, so this is where you need to go and investigate! What's the aesthetic? What's happening in the space? Who's hanging out there? What are the core values?

Part of this approach is speaking to what we call 'leading-edge' consumers. There are people who are super passionate about a particular subject, and can talk articulately about this subject. When you pair future trend reports with the perspective of leading-edge consumers and then mainstream consumers, you can start to see a trend trajectory emerging, which is really helpful for giving brands who are targeting mass audiences recommendations on what is likely to be popular in the future.

Beyond specific briefs and topics, it's also crucial to keep an open mind at all times, so that wherever you are, you spot interesting and unusual things around you. This involves observing with all your senses, not just your eyes. Take loads of notes and pictures as you go. Individual spots may not have

a specific significance at the time, but once you start to build up a catalogue of 'signs of change', you start to realize that an emerging theme or trend sits behind them. Trends research expert Els Dragt really believes in this approach, and it is something graphic designer Alan Fletcher called 'The Art of Looking Sideways'.

How do different aspects of culture intersect (e.g. film, music, sport, fashion)? And how important is it to interact with all of them to inform creative work?
The intersection of different cultural aspects is where the most exciting innovation happens. Music and fashion, for example, are natural collaborators, and many subcultures are rooted in both. For instance, grime culture in the UK has an urban and rebellious aesthetic, which reflects its underground, inner city cultural heritage. Likewise the photographic and filmmaking style that creatives in the space use is raw and uncompromising, mirroring the challenging and often political nature of grime lyrics and its musical style.

It doesn't make sense to look at a single cultural aspect in isolation, because only together do they start to reveal the true story. They reveal the mission and values of the group, and bring the scene to life. That's what you need to understand and portray if you're going to authentically represent a subculture.

Today, we can see more and more creatives pushing the boundaries on cross-culture collaborations, driving unusual and unexpected combinations that feel fresh and exciting. Digital connectivity and social media have democratized this process – making it possible for an illustrator in Yemen to collaborate with a musician in California. Researchers need to stay on top of these new forms of collaboration, as it will bring new types of cultures to investigate.

How has researching culture shifted with the dominance of social media?
As touched on in my previous answer, social media has opened up a world of cultural possibilities. Everyone is a creator, curator and critic, and interactions between people can quickly spur new movements that take hold across the world.

This raises questions around the importance of 'place' in studying culture. Does a culture need to have a physical home, or can it exist in the minds of people who are only digitally connected?

Given this question, when researching culture today, it's important to look at the digital conversations and communities that are forming, as they can reveal a lot about changing cultural values, and how human needs are being expressed. For example, eSports is a topic we explored recently in a project with Twitter, and we found that platforms like Twitter and Twitch play a major role in galvanizing

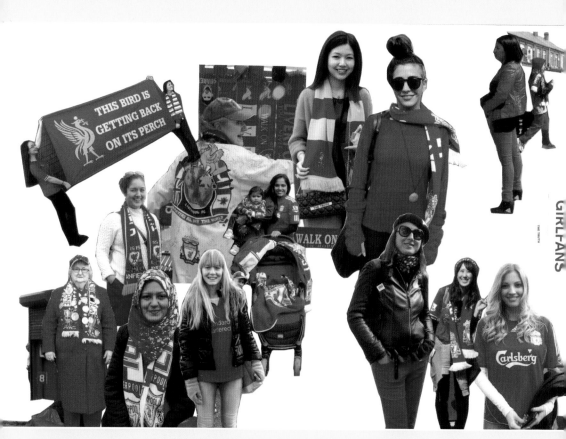

Figure 2.14 **A collage explores how female football fan culture and fashion intersect.** Photography: Jacqueline McAssey and Alex Hurst. Collage: Jacqueline McAssey.

these communities and helping them to grow. Once relationships are established here, they then meet up 'IRL' at eSports tournaments and other gaming spaces. Social media is pivotal to how the culture is developing, so needs to be looked at as a key component.

How do you continue to expose yourself to new and challenging material?
I read a range of different magazines and books, watch documentaries and listen to podcasts, trying not to just engage with stuff I naturally relate to. It's important to challenge my perspective. I also attend a lot of events where people are debating big issues of today, and generally try to keep my eyes open to new cultural things happening, speaking to interesting people wherever I can about their view on the world.

Do you have any observations about the culture of fashion at the moment?
Fashion is experiencing a major cultural shift right now, and that's largely driven by consumer demand for sustainability. The pressure is on the industry to dramatically reduce its impact, and in turn, core cultural ideas around 'new trends' are being challenged. As ideas around capsule and rented wardrobes become popularized, this is likely to impact what people look for in their clothes. 'Timeless' fashion, which is something that has previously been reserved for the wealthy, may become a mainstream phenomenon.

Beyond sustainability, I'm also fascinated by the rise of people like Virgil Abloh in the high fashion world, by people like Victoria Beckham talking about 'comfort' as a primary consideration for her fashion week collection and by the rise of aesthetics like 'afrofuturism'. The conversation is changing to something much more raw and real with more diverse, international reference points. I think social media has played a huge role in this, and people will continue to demand looks and garments that challenge the old guard of the fashion world, and reflect the creative and practical desires of people around the world.

How is the role of a creative changing with the rise of multi-channel platforms and 'hyphen' careers?
The modern world of work demands adaptability. Creatives are expected to be proficient in a range of different skills if they are to stay relevant and keep up with changing technology. Likewise, how we define ourselves as people has become more fluid, and it's accepted that you don't have a single 'thing' that sums up your value or career.

These factors come together to drive young creatives to add many strings to their bow, and to constantly refresh who they are. While this is exciting and will likely drive lots of output, the pressure on individuals to change up what they're doing could have an impact on specialist creativity and craftsmanship long term.

Photography

Just as fashion awareness is a prerequisite for stylists, a basic knowledge of photographers and their work is also important. Photography as a creative medium is accessible and inspiration can stem from the composition, colour, mood or narrative in a photograph. Similarly, you can take inspiration from photography that isn't fashion specific. Photography research is easy: there will be plenty of photography books in your local or college library and there are millions of images on the internet and social media; look out for photography exhibitions in museums and galleries as well. It is good to study the important fashion photographers and be able to recognize their style of work; it is helpful when looking for references. Here is a list of well-known photographers whose work encompasses the photographic fields of fashion editorial and advertising, portraiture, documentary and art.

Katie Grand

Katie Grand met designers Stella McCartney and Giles Deacon whilst studying fashion design. She went on to work with Jefferson Hack and photographer Rankin on *Dazed & Confused* in the early 1990s and was also fashion director at the now defunct *The Face* magazine. She left Dazed in 1999 to launch *POP* magazine, which embraced celebrity covers such as Madonna, Kylie and Liz Hurley and has recently launched *Love* magazine. Grand has also worked as a consultant to fashion labels Bottega Veneta, Louis Vuitton and Prada.

Influential photographers

Alisdair McLellan, Annie Leibovitz, Bela Borsodi, Campbell Addy, Cecil Beaton, Cedric Buchet, Chen Man, Corinne Day, Craig McDean, David Lachapelle, David Sims, Deborah Turberville, Diane Arbus, Ellen von Unwerth, Guy Bourdin, Helmut Newton, Herb Ritts, Ian Rankin, Inez Van Lamsweerde, Irving Penn, Jamie Hawkesworth, Juergen Teller, Lee Miller, Louise Dahl-Wolfe, Magnus Unnar, Man Ray, Marcus Piggot, Mario Sorrenti, Martin Parr, Mert Alas, Nadine Ijiwere, Nick Knight, Patrick Demarchelier, Peter Lindbergh, Petra Collins, Quil Lemons, Ren Hang, Richard Avedon, Ruth Ossai, Sarah Moon, Steven Klein, Steven Meisel, Tim Walker, Toni Frissell, Tyler Mitchell, Vinoodh Matadin, Vivienne Sassen, Wang Ziqian, Wolfgang Tillmans.

Figure 2.15 A group of models behind the scenes at a catwalk show. Photography: Lauren Roberts.

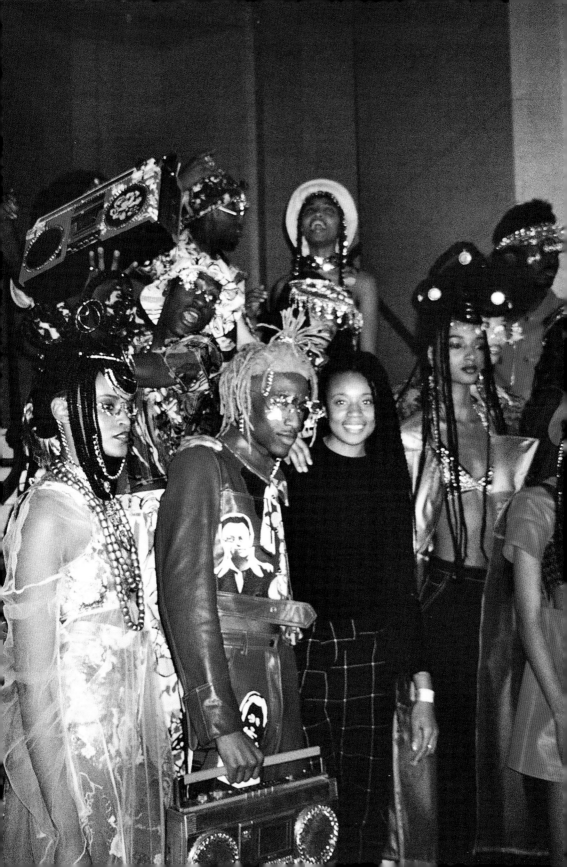

Art

Before photography existed dress styles were documented via artistic impressions, such as drawings and paintings. The composition, subject matter, colour and texture found in paintings, drawings, prints and sculpture are all sources of inspiration for styling. Would-be stylists should know about the significant movements in art and design that have influenced fashion, architecture and furniture design, such as Art Deco, Art Nouveau, minimalism and Modernism. Surrealism, in particular, heavily influenced fashion design and photography; this can be seen in the collaborative work of artist Salvador Dalí and designer Elsa Schiaparelli or the photography of Man Ray. It is still a strong influence in fashion – think about the exaggerated silhouette in the collections of Victor & Rolf or Shona Heath's set designs in Tim Walker's photographs.

Consider, too, contemporary art practices, such as digital art, performance art and installations; visit museums and galleries to appreciate art first-hand.

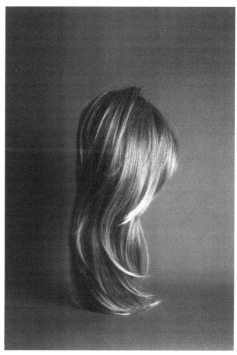

Figure 2.16 **A surreal, fine-art photograph of a wig.** Photography: Sarah Eyre.

Film

The depiction of fashion and style in films is of great value to stylists and continues to provide a great source of inspiration to photographers. Depending on your discipline, films may appeal to you on different levels. Films are personal choices and we all have varied tastes: someone may have a passion for American B-movies while someone else may be enthralled by epic costume dramas. Film influences needn't be taken literally, such as copying the costume worn by a character; other cinematic references may be used, such as location or lighting; throughout the film or in a single scene.

The iconic films listed here are suggested viewing. In some instances they define an era, such as *The Great Gatsby,* which portrays dress in the 1920s; others document the styles of a social group, such as mod culture in *Quadrophenia.* Some films have particular fashion connections, such as *Blow Up* (1966), which features an erotic shoot scene with 1960s model Verushka, and *Funny Face* (1957) for which photographer Richard Avedon was a creative consultant. The costumes in *The Fifth Element* (1997) were designed by Jean Paul Gaultier. Fashion designer Tom Ford wrote the screenplay for and directed the film *A Single Man* (2009).

Figure 2.17 Film still from *The Adventures of Priscilla, Queen of the Desert* (1994), dir. Stephan Elliott, PolyGram Filmed Entertainment.

Iconic films

Youth culture: *The Wild One* (1953); *Rebel Without a Cause* (1955); *Quadrophenia* (1979); *The Breakfast Club* (1985); *Heathers* (1988); *Clueless* (1995); *Kids* (1995); *This is England* (2006).

Drama/action/suspense: *Rear Window* (1954); *Breathless* (1960); *The Birds* (1963); *Bonnie & Clyde* (1967); *The Thomas Crown Affair* (1968); *A Clockwork Orange* (1971); *Don't Look Now* (1973); *Taxi Driver* (1976); *Mad Max* (1979); *Scarface* (1983); *Top Gun* (1986); *Boys n the Hood* (1991); *True Romance* (1993);

Pulp Fiction (1994); *Trainspotting* (1996); *American Psycho* (2000); *Moonlight* (2016); *Get Out* (2017).

Erotic: *Gilda* (1946); *And God Created Woman* (1956); *Belle de Jour* (1967); *American Gigolo* (1980); *Betty Blue* (1986).

Fantasy/sci-fi: *Metropolis* (1927); *2001: A Space Odyssey* (1968); *Barbarella* (1968); *The Stepford Wives* (1975); *The Shining* (1980); *Blade Runner* (1982); *The Matrix* (1999); *Eternal Sunshine of the Spotless Mind* (2004); *Black Panther* (2018).

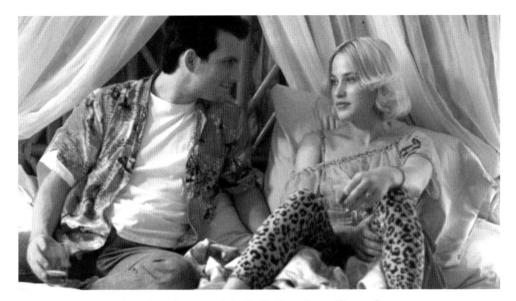

Figure 2.18 **Film still from *True Romance* (1993), dir. Tony Scott, Warner Bros.**

Romantic: *Roman Holiday* (1953); *Love Story* (1970); *The Way We Were* (1973); *Pretty in Pink* (1986); *Mannequin* (1987); *Pretty Woman* (1990).

Musical/dance: *The Red Shoes* (1948); *An American in Paris* (1951); *My Fair Lady* (1964); *Grease* (1978); *Romeo & Juliet* (1996); *Moulin Rouge* (2001).

Historical/period: *Gone with the Wind* (1939); *Dr Zhivago* (1965); *The Great Gatsby* (1974); *Out of Africa* (1985); *The Colour Purple* (1985); *Marie Antoinette* (2006).

Humour/satire: *Blonde Bombshell* (1933); *It Happened One Night* (1934); *The Philadelphia Story* (1940); *Some Like It Hot* (1959); *Breakfast at Tiffany's* (1961); *Shampoo* (1975); *Do The Right Thing* (1989); *The Adventures of Priscilla, Queen of the Desert* (1994); *The Big Lebowski* (1998); *The Royal Tenenbaums* (2001).

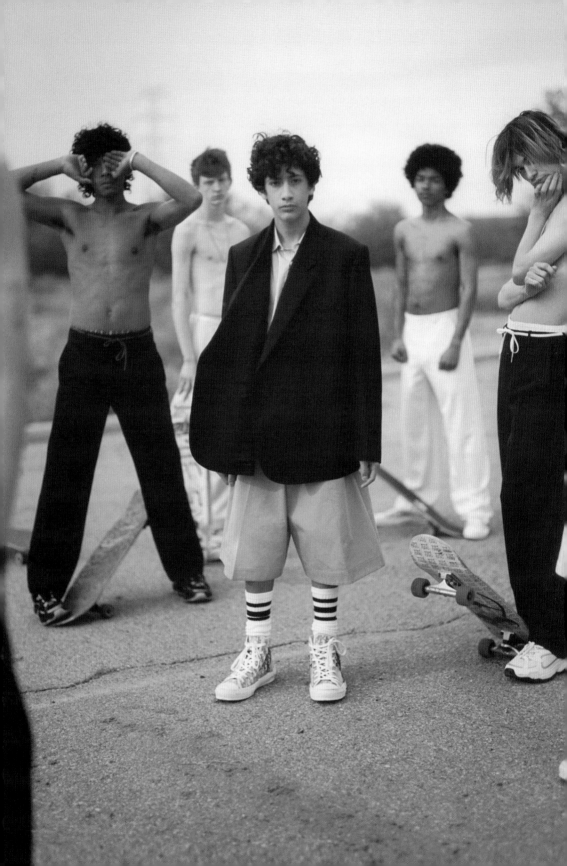

3

Sectors within Styling

Editorial styling

The perceived glamour of working as a stylist is responsible for the surge in styling-related television programmes, magazine articles and college courses. Thanks to its popularity, editorial styling is a highly competitive field. However, with online magazines, blogs and social media, there are now many more opportunities to gain editorial experience, along with the prospect of 'self publishing'.

'I see editorial photography as being about crafting these little separate worlds. It's like creating a little scenario. I'm not sure that's the right word but it's like writing a book and describing an environment. Creating a separate space, a separate reality, is the side of it that I find most interesting.'

Simon Foxton

Figure 3.1 (facing page) **Fashion editorial for *CR Men*.** Photography: Alex Lockett. Styling: Zara Mirkin.

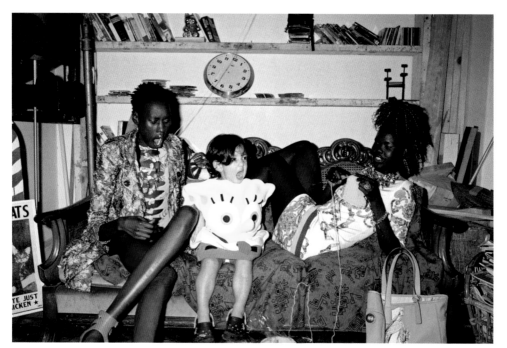

Figure 3.2 'Nu Clean' fashion editorial for *Oyster* magazine. Photography: Milos Mali. Styling: Paul Bui.

Fashion stories

Fashion editorial tells a story through images, often illustrating a theme, mood or concept. Editorial stylists interpret the season's trends, such as the key silhouettes, colours, prints and fabrics through these stories. The fashion editor and their team are responsible for the tone of the fashion editorial and how it will appeal to the readership; the same fashion trend, such as pastel-coloured summer dresses, will be styled and photographed in very different ways according to each publication. The editorial is also determined by the season, such as coats in winter or swimwear in summer.

Alternative publications may offer a more conceptual view of clothing by showing trends that emerge from the street or from art; perhaps a shoot is inspired by an object, the model or the location. Some magazines explore a different theme in each issue, which informs the fashion editorial – or vice versa.

Although more visually stimulating than scrolling through an online store, fashion editorial is still above all else a selling tool or a vehicle for advertising revenue. Editorial trend pages feature outfits that have been put together to inform the reader how to wear trends; often they will show how the look has trickled down from the catwalk to the high street, offering the reader a more affordable version of the trend.

Figure 3.3 Fashion editorial from *The Guardian Weekend* magazine. Photography: Ezra Patchett. Styling: Clare Buckley.

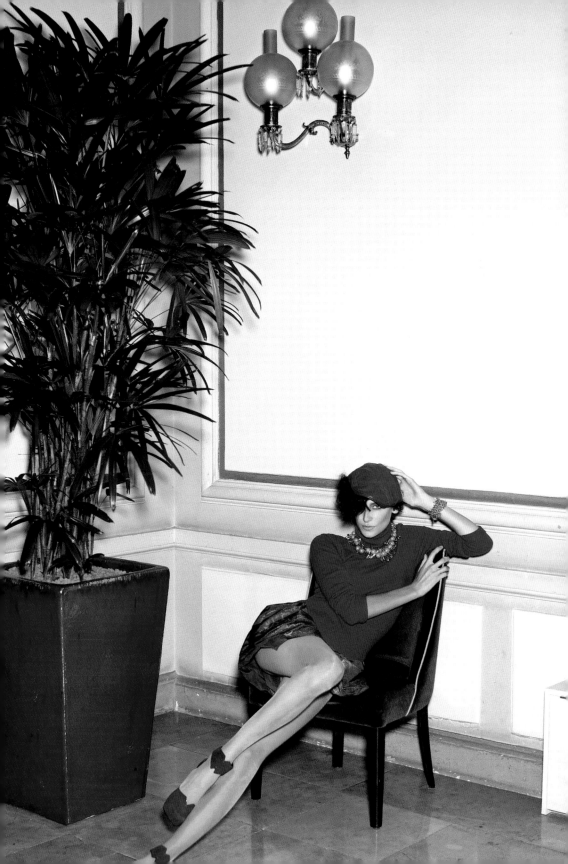

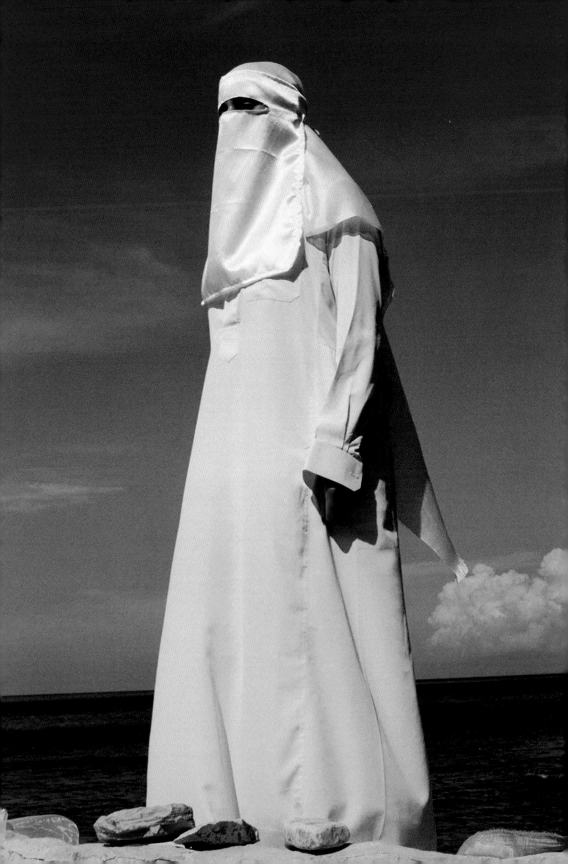

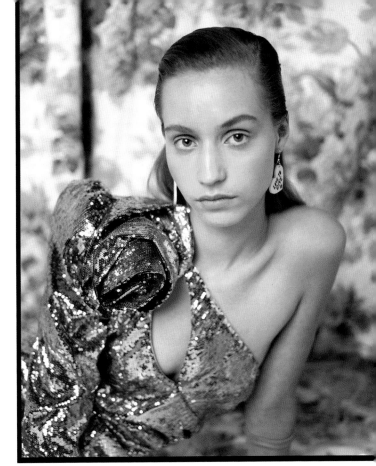

Figure 3.4 (facing page) **Editorial for** *AZEEMA*. Photography: Jameela Elfaki.

Figure 3.5 (right and below) **'Velvet Crush' for** *Yoko* **magazine**. Photography: Xanthe Hutchinson. Styling: Bethani Gowland.

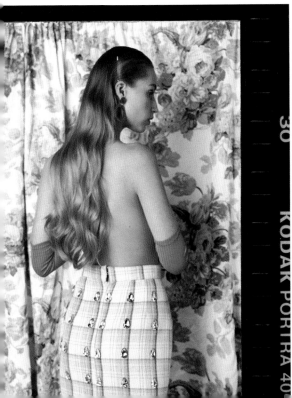

Figure 3.6 (overleaf) **Yvonne, 2018**. Photography: Alex Lockett.

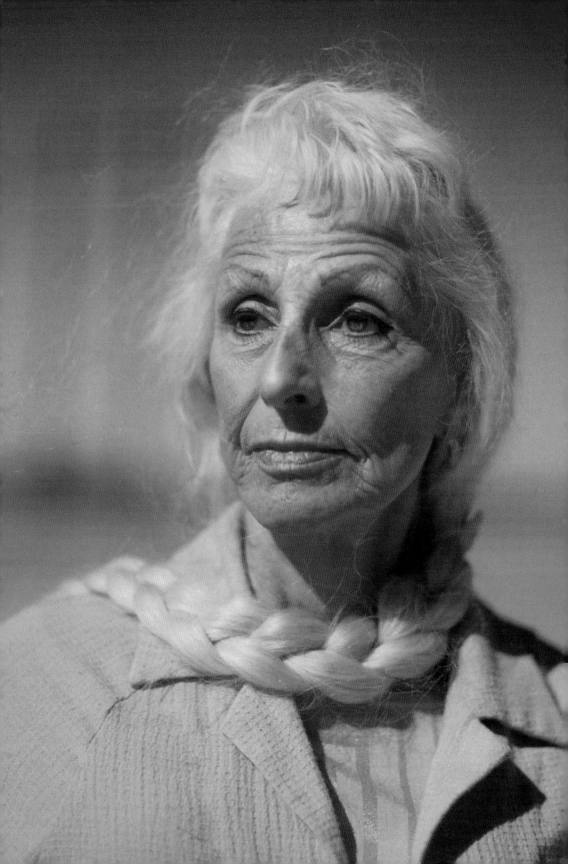

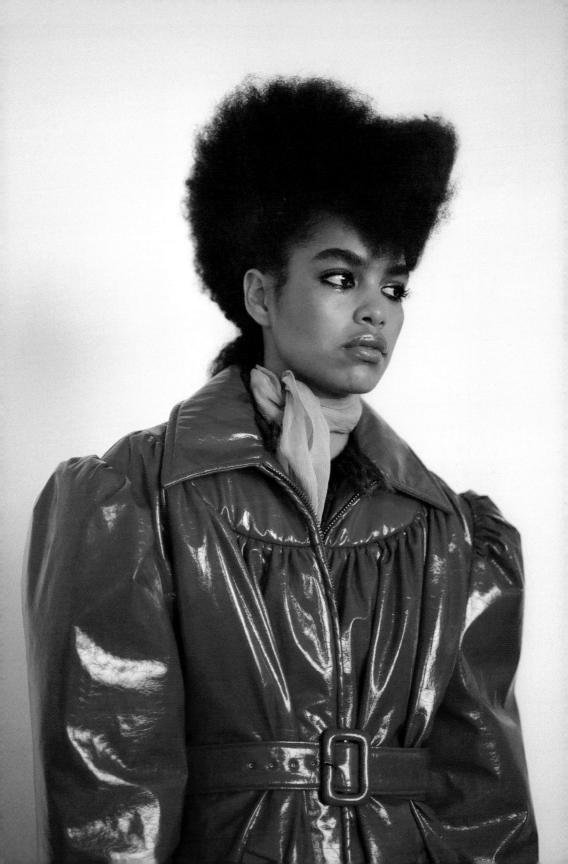

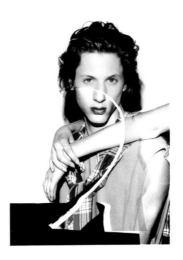

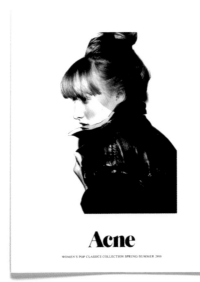

Figure 3.7 (previous page) 'Homage to the Electrifying Eighties', for *Indie* magazine. Photography: Mia Clark. Styling: Megan Mandeville.

Figure 3.8 Acne lookbook, with artwork by Patrick Waugh.

Commercial styling

Commercial styling is used to sell fashion products and services to a specific audience. Commercial imagery is transmitted through traditional promotional channels such as television, cinema, catwalk shows, on billboards (at the roadside, train station or airport) and in magazines and catalogues – both in print and online. In the retail environment, commercial fashion images are commonplace in shop fronts (physical or digital), at the point of purchase (POP) or in promoting the arrival of a new store – an entire building can be covered with an advertising message.

The commercial stylist

The commercial stylist will work with an array of clients on many diverse projects. The client is the linchpin of the commercial project and, as such, the stylist has to be client-focused. The commercial team can be larger than an editorial team. Working alongside the stylist will be the client, who may be someone in the brand's marketing team, or a designer who represents their own label; there may also be an advertising agency representative. There will be a creative team – director, art director, photographer, hair and make-up artist – as well as the models or actors. There may be even more people involved, depending on the brief. It is important for the stylist to be a team player, in order to work with other ideas and suggestions during the creative process.

Editorial styling generally offers more creative freedom than commercial styling; however, there can be greater financial rewards from e-commerce and advertising. It is common at a high level of the fashion industry for stylists who have learnt their craft on magazines to go on and work on major advertising campaigns for international designers and brands; often working with the same team of photographer and make-up artist. This is why the relationships you form with your peers are especially important. A commercial client may approach an experienced photographer to shoot an advertisement, who will then suggest you as the preferred stylist to work on the job.

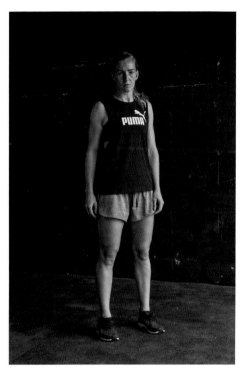

Figure 3.9 **Professional footballer Siobhan Chamberlain poses for a Tuto campaign.** Photography: Ross Cooke. Styling: Creative Players.

Fashion advertising

Advertisements communicate a message or tell a story to a target market; all of which will be contained within a 'brief'. The client will discuss the brief with the stylist and the creative team before the shoot, in order to begin thinking about the model, location, clothing and props. Sourcing clothing for commercial projects differs from sourcing for editorial: in fashion advertising the images will promote just one brand, retailer or designer and most likely will have already been selected. It is often the fashion buyers, having planned and bought the ranges for a coming season, who will know what the key styles are and what they expect to sell. They, along with representatives from the brand's marketing team, will select these important pieces for the commercial shoot or film.

The focus of this type of commercial advertisement is the clothing or an accessory and as such the visibility of the product is key. The stylist is employed to ensure the clothes are pressed, fit the model well and look their best throughout the shoot. There are, of course, always exceptions. If, for example, an accessories brand wanted to create a fashion advertisement featuring a shot of a model holding a leather handbag, then the stylist would have to source clothing, footwear and jewellery from elsewhere to complete the look, but always in accordance with the client's vision and brief.

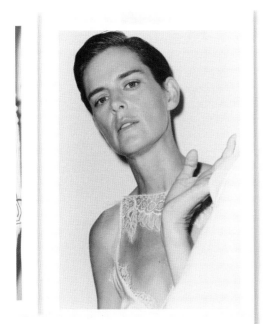

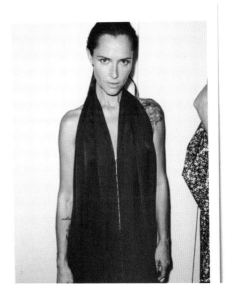

Figure 3.10 **Commercial shots for Victoria Beckham 10 year anniversary.** Photography: Andrew Vowles, Styling: Joe Mckenna.

E-commerce

E-commerce refers to retailing which is conducted online. The sector was pioneered by shopping platforms such as Yoox, Net-a-Porter and ASOS. Since the early 2000s e-commerce has become increasingly popular spawning a shopping revolution. The process involves working with a set amount of clothes to photograph (as many as 150 garments per day) and styling them according to the brand's visual guidelines. The number of products and the speed at which they are continually uploaded means that, in order to meet the demand, stylists have to work extremely quickly and accurately. Fashion customers need to be able to view products quickly and closely. Consideration should be given to the product details so it's important the stylist prepares the garment for shooting, avoiding the need for retouching later on. Details such as colour, fabric and texture, trims and details have to be as clear as they will be under scrutiny (by the creative team and customer). E-comm usually requires a photograph of the front and back, and possibly a side view, as well as close-up shots that highlight a print, for example, or embellished detail. Film clips are also used by online retailers giving customers insight into how a garment fits and moves when worn.

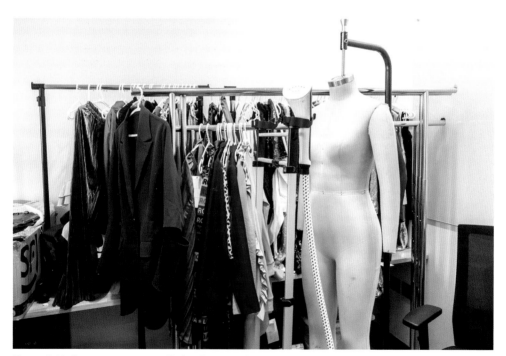

Figure 3.11 **An e-commerce studio is a busy environment, and it is the stylist's job to keep the clothes pristine throughout the shoot, steaming, hanging and prepping each look.** © Bloomberg via Getty Images.

Content creation

Due to an increasing amount of communi-
cation, platforms brands have a need for a
large amount of content to populate their
social media feeds, websites and blogs
to continually engage their audiences.
Some brands have dedicated content
creation teams that will include a stylist
whose role it is to deliver a consistent
visual aesthetic. They may style a model
or arrange flat lays in line with the latest
trends or collections. See the Still-life styl-
ing section for insight into more specific
techniques.

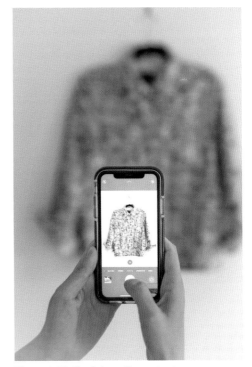

Figure 3.12 **Social media content can range
from simple product shots to fully produced
photoshoots with models.** Photography: Sam
Forbes-Walker.

Lookbooks

Lookbooks feature pages of fashion products listed by name or code. The stylist will glance through a lookbook and request specific samples for a shoot from the designer or from a PR agency. It's a good resource for stylists but also represents a line of commercial work just as with any other type of brochure.

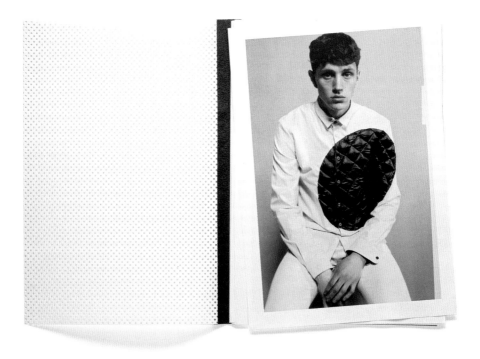

Figure 3.13 Lookbook for designer Martine Rose. Art direction by Patrick Waugh. Photography: Tung Walsh. Styling: Richard Sloan.
Accessories lookbook for Lucie Flynn. Art direction by Patrick Waugh.

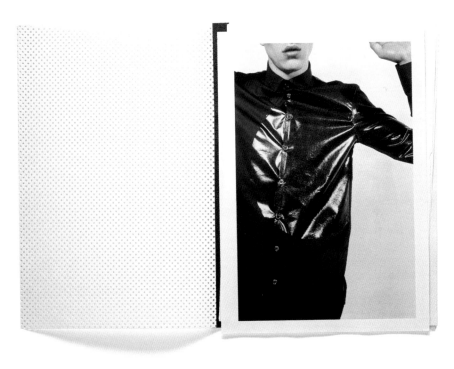

LUCIE FLYNN

Film

Film's place in fashion is broad-ranging, encompassing e-comm clips, TV adverts, music videos and fashion films. It spans both commercial and editorial projects, for example, Nick Knight's SHOWstudio forged the way in the field of conceptual fashion film making. It broadcast live from behind the scenes at photoshoots and fashion shows as well as collaborating with leading designers, models and stylists on a variety of multimedia projects. While we may think of film in the context of cinema, film within fashion can be short clips of content for social media channels or a live-streamed fashion presentation.

Fashion garments worn on film will be viewed from all angles; therefore, one of the main responsibilities of the stylist is to ensure the clothes fit the model as perfectly as possible. The clamps and pins used to adapt garments for a still image are clearly not acceptable on film.

'[There] were certain things that I believed in when we started SHOWstudio. One was process, the second was performance and the third was moving fashion.'

Nick Knight

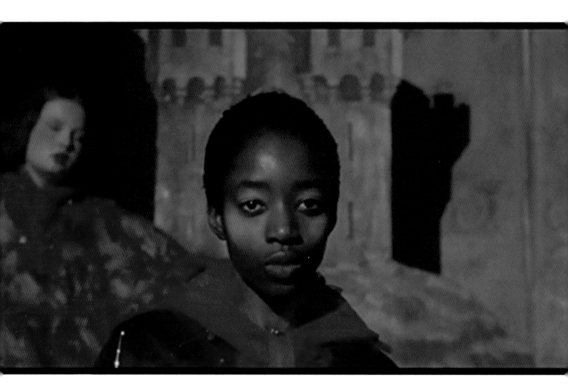

Figure 3.14 Still from a film created to showcase a Simone Rocha collection on SHOWstudio. Cinematography: Petra Collins. Creative direction: Simone Rocha and Petra Collins.

Fashion shows

Fashion shows offer great opportunities for stylists to employ their creativity and talent, whether they are a high-production event for a major designer, a retail fashion event for a shopping centre or a small-scale, low-budget show at a college. Some argue that fashion shows are outdated because of their exclusivity and expense but because of increased access online they remain a valuable resource for stylists. The traditional fashion show calendar operates six months ahead in order to allow buyers in-store to select products for the next season; however, this model is evolving. 'See now, buy now' is a quick-turnaround framework which designers such as Burberry and Alexander Wang have adopted. This allows buyers and customers to purchase directly after a show.

A stylist will work closely with the designer or brand on the vision for the fashion show ensuring it represents the ethos of the brand and communicates the inspiration behind the collection. A fashion show is a division of labour and it often requires a show producer to coordinate what happens before and during the event. However, depending on the scale of the show, a stylist may have a greater involvement than making the clothing look good on the runway; decisions have to be made on lighting, choreography and music. If styling fashion shows appeals to you it is wise to start backstage as a dresser, where you will witness the excitement, and chaos, behind the scenes. Learning how to dress a model within a given time frame gives budding stylists vital insider information on the styling techniques that will or will not work. At smaller shows, where changeovers are fast and models have to get back to the catwalk quickly, it is not always possible to change items such as hosiery or gloves so styling ideas have to be adapted.

'You have to get into the designer's mindset. You are there for them 24/7. So much time, love and care goes into it.'
Sophia Neophitou

Fashion presentation

The fashion presentation has emerged as an alternative to conventional fashion shows. Rather than walking down a runway, models will interact with a set, standing or sitting for the duration of the event. Music, lighting and atmosphere are still as crucial to a fashion presentation but this format is often less formal and may invite audience interaction. While the outcome is different to a fashion show the stylist's role is broadly the same.

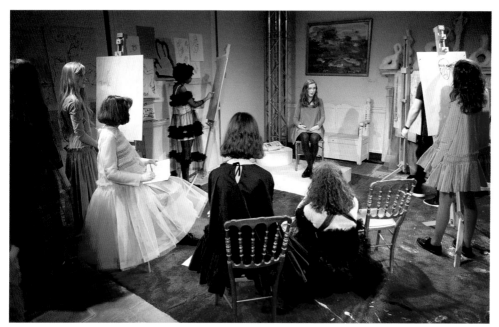

Figure 3.15 **Molly Goddard created a life drawing class for her fashion presentation.** Photography: David M. Benett, via Getty Images.

Styling a non-fashion advertisement

We are exposed to fashion advertising everywhere, but take another look around you. Consider the clothing worn in adverts for companies such as banks or super-markets. A stylist will have sourced and selected the clothes and styled every person or actor. Commercial stylists will not necessarily follow fashion trends but will know how to develop the clothing for a given character within a commercial brief (see the 'A typical commercial brief' box).

It can be difficult to borrow clothes, unless a stylist has good contacts with PR agencies, because there are no clothing credits. In most cases there will

be a budget to allow the stylist to buy the clothing. If more specialist items are needed then appropriate clothing, props and furniture may be hired for a fee. Jobs that require a specific costume, such as a military uniform, not only test the stylist's sourcing ability but also their historical and cultural knowledge of dress.

If a high-profile celebrity wears clothing in an advert, the PR representative can generate media coverage (free publicity) for the brand by promoting the fact that the celebrity is wearing the clothes. It also occurs when celebrities wear clothing for television appearances or red carpet events, which is then picked up in the style press.

Activity 1: A typical commercial brief

This example is for a global sneaker brand

The objective: Develop the look and mood of the current season collection with portraits, product shots and short film clips. Referencing local youth culture making an impact globally, the heroes of the story will be young creatives from a variety of backgrounds.

Mood:

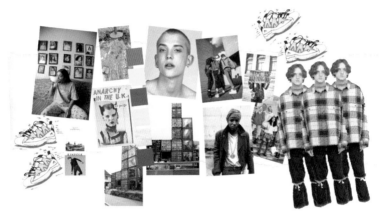

Figure 3.16 **A selection of images collated to capture the mood of the shoot.**

Talent:

- Lisa – graphic designer and grassroots activist.
 Clothing size: 18. Shoe size: 7. Primary colours, bold prints, sustainable focus, vegan materials.
- Jamal – musician and youth worker.
 Clothing size: XL. Shoe size: 11. Premium denim, clean lines, workwear silhouettes, earthy tones.
- Sam – illustrator and community volunteer.
 Clothing size: 10. Shoe size: 5. Oversized silhouettes, ethical tees and premium jersey basics, tone-on-tone.
- Marc – photographer and guerrilla gardener.
 Clothing size: M. Shoe size: 9. Overalls, turtlenecks, selected mid-century vintage pieces, monochrome with pastel accents.

Shot list:

- Two full-length portraits per person
- One group shot featuring all talent
- Five product close-ups per person
- 60-second film per person.

Still-life styling

It is not just clothes that drive fashion businesses to economic success. Traditionally, fashion houses have relied on perfume, handbags, shoes, beauty and lifestyle products to generate revenue. Still-life presentation is used within all areas of the fashion industry and it is an essential component in marketing these products for designers and brands.

Catalogue still-life styling tends to be product-focused and may highlight a garment's colour, specific details such as an interesting button or trim, or the choice of colourways available. For editorial or commercial still-life styling there is usually a more conceptual or surreal approach, where the product fits into a story or helps to communicate an advertising message. Beauty products, cosmetics and accessories sit happily in these concepts because of their size.

From magazines and brochures to e-commerce and social media, brands will always need the expertise and flair of still-life stylists to help them display products to their full advantage.

'In still-life photography, everything can be investigated in so many more and different ways. There are endless possibilities and each one of them has the potential to eventually change our perspective.'

Bela Borsodi

Figure 3.17 **Still-life beauty editorial 'Paint it pastel' for *Russh* magazine.** Photography: Milos Mali. Styling: Clare Buckley and Kym Ellery.

Figure 3.18 **Still-life takes many guises. This hi vis jacket slung over a washing line is an example of the 'accidental' still-life that's all around us.** Photography: Lucy Hayes.

Visual display

Many of the techniques used to display beauty products, clothes and accessories are comparable to those used by visual merchandisers (retail display and window designers). Still-life stylists and visual merchandisers will both consider composition, proportion, scale and the use of colour in a still-life installation.

Concepts in still-life

Still-life in fashion editorial and advertising is becoming more innovative, artistic and fantastical; it can be difficult to unpick where the styling and photography ends and the digital editing begins. On the following pages you will see some creative examples of still-life styling. Some of the clothing and accessories are styled in an unconventional manner, but they are still at the heart of the image.

Figure 3.19 **This Dover Street Market display riffs on the idea of a playground, with a slide and climbing frame used to display the clothes creatively.** Photography: David M. Benett, via Getty Images.

Figure 3.20 **Sock puppets are styled and accessorized to create playful characters in this still-life shoot.** Photography: Isaac Mellalieu. Styling: Anna Latham.

Still-life techniques

The following methods are widely practised in commercial still-life styling. You will find examples in many types of advertisements, e-commerce and social media content. Still-life stylists have an eye for the smallest detail; they are good at handling and draping fabrics and will have excellent pinning techniques. This method of styling is quite precise and would appeal to those who like to get things just right, although there is an additional pressure of being precise whilst working at a fast pace. Online shops feature pages and pages of products and you must have the ability to work quickly.

Location

Shooting still-life in a location commu-
nicates a lifestyle to suit the product.
This lifestyle may be either functional or
aspirational.

Suspending

A popular method in still-life styling is to
suspend the garment, either in a studio
or on location. This works well when the
garment already has a strong silhouette
when flat, as illustrated here. Otherwise
it will look lifeless, which is commonly
described in fashion design and retail as
lack of 'hanger appeal'.

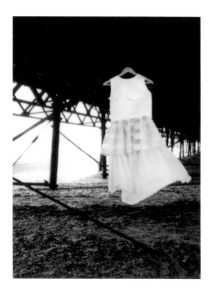

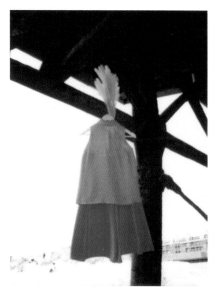

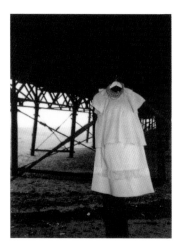

Figure 3.21 (a–h) **Still-life editorial using a pier as a moody backdrop for suspended dresses.** Photography and styling: Tara McKenzie.

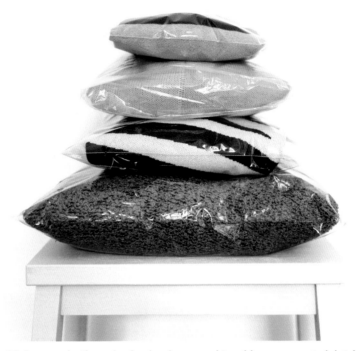

Figure 3.22 In this image, plastic packaging has been used to add an unexpected detail to a stack of folded knitwear. Photography and styling: Sophie Benson.

Stack

A stack is used to show a customer the same garment in a variety of colourways. They can be made to look ultra neat or have a purposefully crumpled look. The crumpled texture is achieved by arranging tissue paper inside the garment, which allows the stylist to manoeuvre the folds and dents, and keeps them in place for the duration of the shoot. Wadding is also placed between the garments to give the stack more height and avoid sinking, particularly in the centre.

Flat lay

A 'flat lay' is a series of product, laid out and photographed from above. Flat lays may be full outfits or individual products chosen to complement each other. This method is popular with fashion brands as it helps customers envisage how products will work together. In this flat lay, the stylist has followed a colour theme, bringing together a variety of props and accessories to create a single palette. Different textures, tones and print are used to create depth and interest;

there's something new to spot with each view.

Another way of displaying a garment, such as a shirt or a dress, in a more lifelike pose is to use a mannequin. Tissue paper is used to pad and shape the garment and give it a 3D silhouette; arm fullness is created by rolling up tissue paper and forming them under the shirt sleeves. The mannequin can then be digitally cut out of the shot, leaving a more three-dimensional silhouette behind. Mannequin imagery is often used in place of, or as well as, a model on e-commerce sites.

Figure 3.23 **It takes trial, error and patience to make all the elements of a flat lay work in harmony. Shape, space, placement, texture, tone and visual hierarchy all need to be considered.** Photography and styling: Imke Oppenkamp.

Personal styling

Personal styling encompasses image and colour consultancy, one-to-one styling and shopping guidance for private clients or styling advice for the public. This area has seen rapid growth and publicity in recent years, with the rise of the individual 'celebrity' stylist, and the influence that celebrities themselves have on the fashion buying public. Mirroring this trend, it is now common for retailers at all market levels to offer a personal stylist for all customers.

Working with private clients relies on the stylist being able to communicate effectively. Having excellent interpersonal skills is the key to a successful styling career and for personal stylists this is critical. Giving style advice to the general public can involve a lot of confidence-building as the reasons for a client requiring the services of (and paying for) a personal stylist may be connected to a significant change in their lifestyle, or to more serious issues relating to low self-esteem. This requires knowledge of the subject and being able to deliver and articulate information in a confident yet empathetic manner. A personal stylist should boost confidence and inspire the client to have a more positive relationship with clothing.

Working with celebrity clients, such as actors and musicians, may boast a higher level of excitement and glamour but it is wise to consider that they are still individual people with their own insecurities and issues. The major difference is that they will be exposed to greater scrutiny, and criticism, than the average client.

'Working with a client, I try to get into someone's head and figure out what they want to say, how they're feeling about themselves and the moment.'

Elizabeth Saltzman, who has dressed celebrities such as Gwyneth Paltrow, Saoirse Ronan, Kate Moss and Sandra Oh.

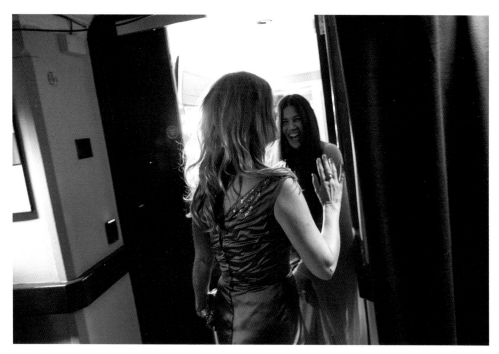

Figure 3.24 Kate Moss and her personal stylist Elizabeth Saltzman laugh backstage at The Fashion Awards. Photography: Garath Catemole, via Getty Images.

Personal styling for individual clients

The services of a personal stylist are, for many people, important in building self-esteem. A successful personal styling appointment should leave the client with the confidence to manage their own wardrobe. For this role the stylist has an assessment with the client to discuss their needs and, more importantly, how the stylist can help them. During the initial meeting with the client, the stylist will consider the following points.

Lifestyle

Clothing has to fit into a client's life-style; they may need help with choosing clothing specifically for work, a special occasion, a holiday wardrobe or a complete capsule wardrobe. The stylist has to be practical and work with the client by suggesting viable solutions.

Figure 3.25 Michelangelo Pistoletto's 'Venus of Rags' is a comment on consumption. Photography: Juergen Schwarz, via Getty Images.

Budget

It is important to be able to offer advice based on the client's budget, which requires good research skills and thorough knowledge of the retailers and what they offer. It is just as important to research clothing, underwear and accessories at the budget end of the market as it is to research high-end designer collections.

Wardrobe weeding

A personal stylist will often carry out a 'wardrobe weeding', which involves sorting through the client's wardrobe, removing any clothes that don't fit, are in a poor condition or are completely out of date. By eliminating these pieces the client will have a smaller selection of suitable clothes and the stylist can then suggest any new purchases to complete the 'new look' wardrobe. Disposing of unwanted or unworn clothes should be done in a responsible and ethical manner.

Celebrity styling

There is no doubt that in recent years this form of styling has had enormous publicity. In some instances the celebrity stylists have become celebrities themselves. At a global level these stylists will be very experienced and will have built excellent contacts with both fashion designers and fashion PRs. To be successful in this field requires confidence in your own ability, excellent negotiating skills and the ability to build good relationships with the clients. This is not a 9–5 job; many stylists will be called on to provide clothing ideas and solutions to problems at short notice and at any time of the day or night.

There are many reasons a celebrity might need the services of a stylist. Practically speaking, if an actor or singer has a busy lifestyle, it is far easier to employ someone who, with an understanding of their taste and style, can research and select the most appropriate styles for them. Celebrity styling is commonly referred to in relation to red carpet events and awards shows. Stylists will, depending on the level of the event, negotiate for months with designers and PRs in order to get their client in the right outfit. Of course, the designer or PR will be selective about who wears their clothing so although it may sound relatively easy, it often isn't.

Stylists often have a signature style, something that makes their work stand out. This, along with their body of work and contacts, may bring them to the attention of a celebrity client. A stylist may be brought in to update or restyle the client to move them in a new direction. It is often the case that a stylist who builds a rapport with the client, who understands them and their style, is more likely to be rehired.

Celebrity styling may seem out of reach to most stylists starting out, but making contact with and offering your services to unsigned musicians, singers and young actors will provide great opportunities for testing your styling ideas, creativity in sourcing and all-important networking skills.

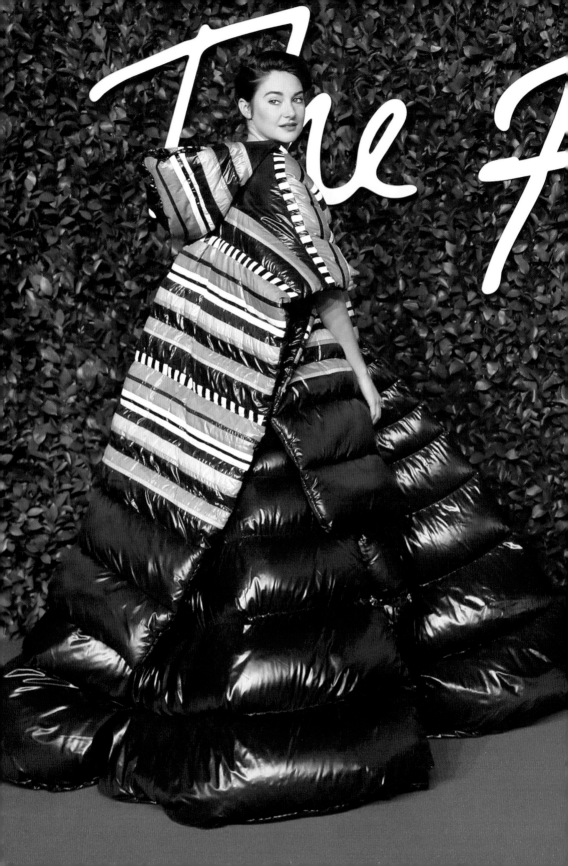

Styling musicians

Stylists are often hired to prepare a musician or singer for a special event, such as a tour, or to provide ideas for an album cover or music video. To some extent bands and musicians will look for something that fits with them and their music. As in commercial styling, sourcing clothes can be easy or difficult depending on the client. Some designers are more than happy to lend their clothes to be worn in a video but it depends if the designer or brand is a good fit with the client and whether or not they will receive publicity from the relationship.

'This [was] the perfect combination of elements to really embody all facets of female existence – strong, bold, powerful, soft, beautiful, edgy, provocative, political and even a bit of masculine/ tomboy energy, which many females identify with.'

Alexandra Mandelkorn

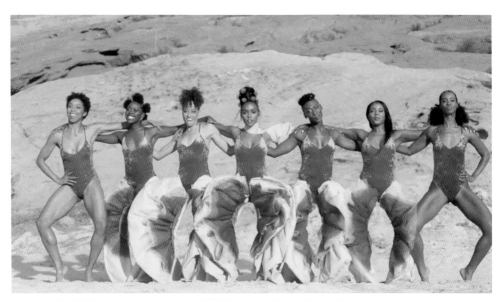

Figure 3.27 Still from Janelle Monáe's 'PYNK' music video. She and her dancers wear coordinating outfits, designed to embody Monáe's vision of femininity. Styling: Alexandra Mandelkorn.

Figure 3.26 (facing page) A successful stylist will encourage their client to be bold and creative with their style, as Shailene Woodley was when she wore a Moncler puffer dress on the Fashion Awards red carpet. Photography: Isabel Infantes, via Getty Images. Styling: Pierpaolo Piccioli.

Interview

Siobhan Lyons

Siobhan Lyons began her career as an assistant stylist to Jacob K and now works as a freelance stylist and consultant.

Starting out

I did an art foundation course followed by a fashion degree at Leeds College of Art and Design. I moved to London six months after finishing my degree; on my own, with no job, nowhere to live and I knew one person. I wanted to do styling and be more involved in fashion and London was the only place to be.

I started working in Gareth Pugh's studio on his latest catwalk collection. After that, I spent days emailing magazines looking for internships. Eventually I got a response and began interning at *Another Magazine.*

Interning is about gaining people's trust and showing that you are reliable, responsible and willing to learn. Yes, I made tea, and yes, I did a lot of what seemed like 'thankless' tasks, but inevitably they all lead to something more worthwhile. I'm glad I stuck it out or else I don't think I would have had all the valuable experience I have now.

Assisting Jacob K

I met Jacob K and became his first assistant for the next two and a half years. You become their second 'brain'; begin to think like them and have to learn to be ten steps ahead.

As an assistant you spend a lot of time emailing and on the phone chasing things up with PRs. It's very difficult as Jacob is not the only stylist shooting. There are hundreds of stylists all shooting at the same time and who all want the same things! It is extremely stressful and things don't always go to plan. You have to give up a lot; it's hard to make plans around work as the schedule will change all the time. Sometimes you are on the road for weeks at a time, shooting back to back. Travelling is one of the best things about assisting; I have been so fortunate to go to amazing places all over the world and assist on jobs and meet people I'd never even have dreamed of. I never knew that I'd begin by tearing up tear sheets and end up doing what I did. I have been very lucky indeed.

Working on a Tim Walker shoot

This shoot was a Tim Burton retrospective, so we were basically going to recreate some of the iconic characters in his films. I had to research fetishwear, find latex cat masks, gloves, stockings. Jacob had selected all the looks he wanted from various designers and catwalk shows; it was then my responsibility to request all these things from various PRs and keep track on their availability.

On this shoot we had twelve trunks arrive from the US from *Harper's Bazaar.* We also had eight suitcases of our own. It is the most we have ever had on a shoot. We shot in the rose fields of Colchester, UK, so we had to set up everything in the barn; not an ideal situation as it was quite dark and dirty, but we managed.

There was a 100-ft skeleton that had been made especially for the shoot, suspended from a crane. I ended up wearing a Martin Margiela all-in-one bodysuit, some crippling knee-high Alexander McQueen boots, and was wrapped head to toe in bandages with a huge mask as the character Jack Skeleton from *The Nightmare Before Christmas.*

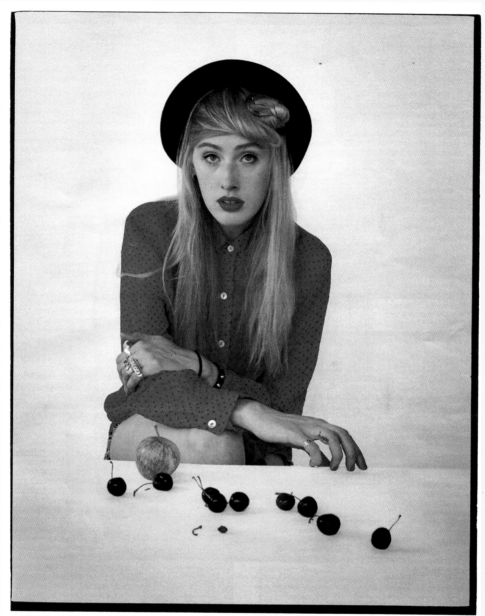

SIOBHAN LYONS, 26. Occupation: Stylist. Style icon: "My mum in the Seventies. She was very free and very beautiful." Theme song: "'All I Really Want,' by Alanis Morissette."

Figure 3.28 Portrait of Siobhan Lyons photographed by Tim Walker.

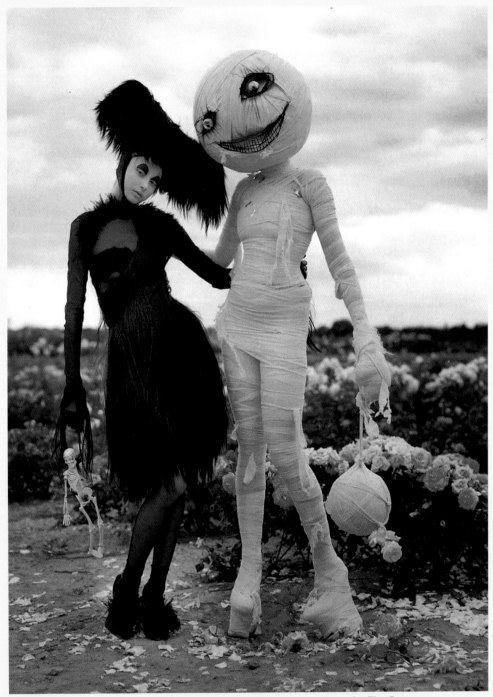

Figures 3.29 (this page) and 3.30 (facing page) **These images are from the Tim Burton retrospective shoot for *Harper's Bazaar.*** Photography: Tim Walker. Set design: Shona Heath. Styling: Jacob K. Assistant stylist: Siobhan Lyons.

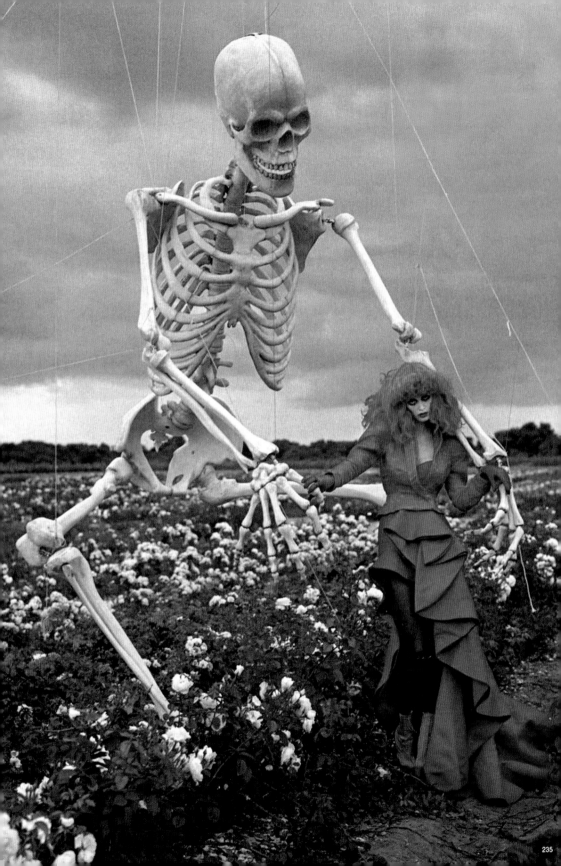

Interview

Emma Jade Edwards

A day in the life of a commercial styling assistant.

Setting up

A typical day would start with a crew call for breakfast any time between 6.00 am and 8.00 am. The shoot could be in a studio or out on a location. If we are shooting in a studio I would have a wardrobe room to set up in. On location I could be on a wardrobe truck, which is essentially a converted van with rails, sink, a washing machine and so on, or inside the unit base, which could be anywhere from a pub to a church or house!

My first job is to unpack and hang the clothing and accessories and fill up the steamer and iron with water. I work closely with the hair and make-up artist to create a look for the actor, model or presenter. The production usually set a timed schedule for the artist to get ready in but if we feel the artist should have make-up first or get into their wardrobe first then we make the decision.

Sometimes the artist may be wearing something delicate that I wouldn't want creasing by sitting in make-up for an hour and production may not know this when they produce the schedule. A big part of the job is to be practical and always thinking ahead. If we have not had a fitting prior to the shoot day then I will do one first thing in the morning to get approval for the outfit; then, while the artist is in hair and make-up, I will press the clothing and hang it, ready to be put on at the last minute.

There are several people who need to approve the clothing: the director; the advertising agency, who writes the concepts; and the client. This requires good people skills, a positive attitude and the ability to explain your choices and back them up in an intelligent and educated manner. There are many opinions; however, it's good to remember you are the stylist and this is your field of expertise.

'A big advantage is having good observational skills and absorbing everyday, commonplace information from style and fashion to music, film and culture.'
Emma Jade Edwards

Working on set

Once the artist is called on set I will go with them and watch the action on the monitor, making sure they look perfect and looking out for any wardrobe malfunctions and continuity issues. Sometimes we can film the artist walking through a door on location on day one and walking out the other side in the studio on day two, so it is essential that the continuity of the clothing matches exactly: the handbag must be in the same hand; the amount of buttons done up must be identical; the scarf must be tied the same way.

The length of day can vary but generally we would work a ten- or twelve-hour day on-camera. At the end of the day I pack everything down and organize the clothes that need to be returned to the stores, hire companies or PR companies.

Aspects of the job

I have a returns or 'de-prep' day to take any clothing back. I also organize my receipts and make sure that everything I have spent tallies with the money I have remaining: managing the budget is a big part of my job as is the prep. I would receive a brief, director's treatment, storyboards, moodboards, artists' sizes and budget information so I can do all of the buying. I mainly purchase the clothing if current trends are needed but sometimes I hire, make or borrow clothing too. It is, of course, essential to be fashion and style conscious and follow trends but it is also necessary to have a solid understanding of fashion and costume history and street style from all walks of life.

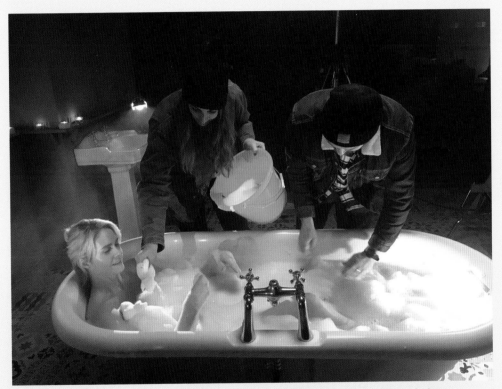

Figure 3.31 Being an assistant means being prepared to attend to a whole range of often unexpected tasks. Here, they add bubbles to a bath on set. Photography: Emma Jade Edwards.

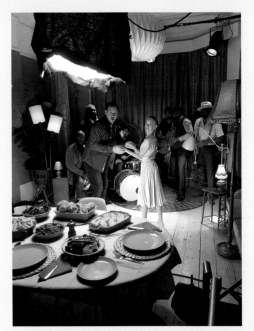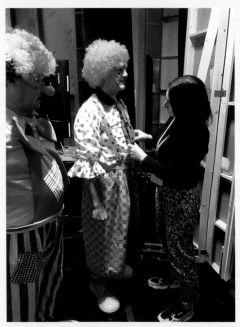

Figure 3.32 **Working as a commercial styling assistant means two days are usually never the same.** Photography: Emma Jade Edwards.

Interview

Carol Woollam

A day in the life of a still-life stylist.

The briefing

As a still-life stylist my clients are mainly mail-order companies. A briefing will have taken place a couple of days or even a week or so prior to the shoot, with the art director, photographer and stylist present. A buyer and/or designer may also be at the briefing if there is a particular detail that needs to be shown or product that needs to be photographed. The briefing will determine how many products will be shot each day; the type of lighting required by the photographer and what props or backgrounds are needed, which will have to be sourced and in the studio ready for the first day of the shoot.

The amount of products to be shot in a day is normally achievable and it can vary from client to client. Some clients have a low-shot rate and low-density pages (fewer products) as the photograph will be used as a selling shot. Other clients will require a quicker turnover; their pages will normally be of a higher density (more products) and will have a model shot as the selling shot.

On the shoot

The budget will have been set by the client and will include photographer, stylist and assistant fees (sometimes a set builder) studio and equipment hire, food and drink and transport.

A typical day on a still-life shoot would start between 8.30 and 9.00 am. When I arrive at the studio, I unpack my styling kit, set up the ironing board and iron and have the steamer filled with water and ready to go. Preparing the products in advance will allow you to foresee any

problems that may arise. It also allows you to check that the products are correct, particularly the size and colour. Depending on the type of garment and how it is being presented, I will press or steam and fold it, if required, ready to place on set.

The creative team will sit down and discuss the order of photography. While the photographer is setting up the lights and set, I will arrange the clothes on the garment rail in the order they are to be shot. If there are both single and multi-product shots, it is usually easier to start prepping the single items to get ahead and give you more time to prep on the bigger shots.

When the garment is placed on the set, a quick snap is taken and viewed on screen to check that it is in position; if correct, the adjustments can then be made. If the garment requires movement, this can be created by using tissue and wadding. Continuous shots are taken until the lighting and product look correct. The art director will overlook the final shot and point out any fine-tuning that needs to be done. A close-up view on the computer screen can reveal any faults that can be corrected.

Sometimes things may not go according to plan and a shot may not work, so clear and constant communication is imperative at all times between the creative team so you are all working on the same level. If the stylist or photographer can foresee any problems with the shot, it should be brought to each other's attention immediately and resolved quickly to ensure that deadlines are met.

Figure 3.33 **Props are carefully sorted and stored ready for the shoot to begin.** Photography: Victor Virgile, via Getty Images.

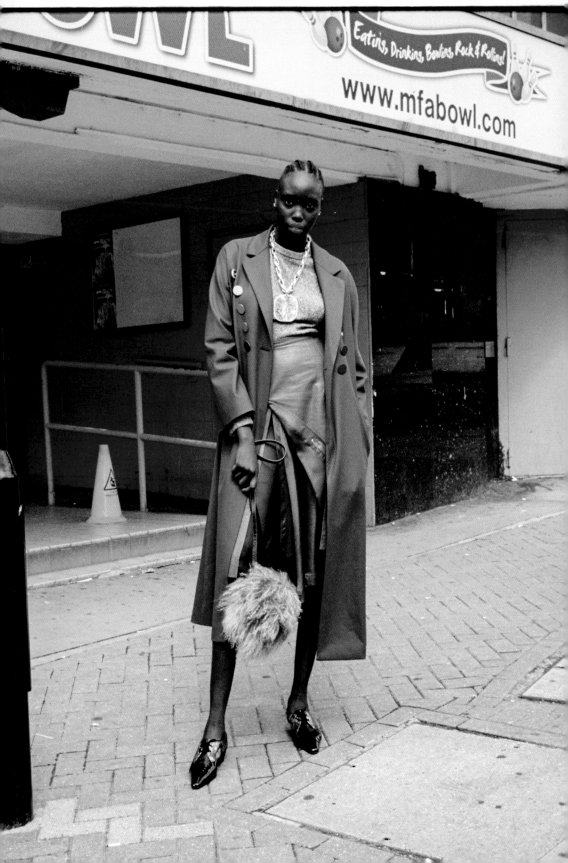

Preparing for a Photoshoot

Working with a team

In order to embark on a career in fashion styling you will need to build a body of work that you can show to prospective employers or clients. If you are not assisting a professional stylist then producing work by means of a 'test' is the best way to try out your ideas. This method allows you to produce images on a minimal budget by working with photographers, hair and make-up artists and models for free. In addition to developing your portfolio this helps you build confidence and develop a more professional way of working. There are many factors to consider when styling a fashion shoot and they don't always go to plan. However, if you are only testing and trying ideas, it doesn't matter as much; it is beneficial to make mistakes early on and to learn from them. A stylist needs to react and adapt to problems and changes that occur during the image-making process. How you deal with these challenges is a key part of the job.

Figure 4.1 (facing page) **'I Could Finally See in Colour', an editorial for *Rollacoaster*.** Photography: Yu Fujiwara. Styling: Masha Mombelli.

Figure 4.2 **Planning for this editorial shoot included casting models, sourcing clothes from multiple cities, styling looks, scouting a location and coordinating travel.** Photography: Tia Millington. Styling: Tia Millington, Charlotte Jones, Lucy Marriott.

Organizing a test shoot

A test shoot is a trade-off; you are all working together to one common aim which is to get usable images for your portfolios. If you are studying an art and design course you will be surrounded by creative students in disciplines such as photography, fashion, textile design, film-making and illustration. It is up to you to seek out people and establish a working creative team. This is also the first step toward networking which, admittedly, some people find easier than others. If you don't have the confidence

to approach people, then think about advertising yourself and skills, by way of social media, online communities or posters in the social areas of your university. Finding like-minded people to work with is imperative and the relationships you make early on in your career can stay with you throughout your professional working life. Ultimately, an ideal team is one in which all members have ideas that merge; one in which everyone works towards the overall art direction.

While you are encouraged to collaborate with other creative people to produce

images it is by no means impossible to produce images yourself. You may wish to take your own photographs, which is possible on small-scale shoots. By using a digital camera or your phone, your own clothes and by shooting at a friend's house or an outdoor space, you can style and produce shots and begin to analyse your own creative identity. You will find, however, that the greater the number of scenes or shots, outfits and models, the more difficult the dual role of stylist and photographer becomes, but it's not impossible. Primarily, a stylist takes care of the clothing and needs to focus on this throughout the shoot. Take your eye off the ball and problems can be missed, until you see them in the final photograph when they cannot be rectified or corrected digitally. In fact, even at the test stage, the production of your shoot may be large enough for you and your photographer to need assistants.

Communication

The complex organization and planning involved for photoshoots requires excellent communication and negotiating skills. The more people involved, the more lines for communication are needed. Some shoots can take weeks to plan and develop; others progress quickly. If specific props have to be sourced or made, or there are special locations to be found, the stylist must undertake a copious amount of planning. The use of social media and messaging apps have all made the organization of a shoot faster and more fluid, particularly for students. Camera phones are useful for casting models or photographing inspirational references to use in a shoot without the need for a lot of equipment.

Now you have to decide on what you and the team are going to shoot. Is the story based on a trend for the forthcoming season? Have you seen an exhibition that has inspired you? Is it a mood you are trying to capture or are you focusing the entire shoot on an item of clothing, shoes or jewellery?

Develop your initial idea by producing moodboards, using references from art exhibitions, film, words, images, sketches, objects and fabric, all of which illustrate a mood or idea for clothing, accessories, hair, make-up and props, along with other images chosen for their colour, texture and graphics. Recording information in this way enables you to visually express your ideas to the rest of the creative team. Ideas can flourish as the group responds to this information, adding their thoughts on the shoot idea and how they might visualize and interpret the story. The team may start with a small idea that could conceivably expand into a set of ten images, so being able to visually and verbally communicate your ideas is paramount.

The photographer can propose lighting ideas, suggest locations and identify equipment needed for the shoot. The hair and make-up artist can also contribute ideas, considering such aspects as shape, texture and finish, and will identify any specialist requirements, such as hair pieces, unusual colours, body paint and so on.

'It's important that you are sure that you share the same sensibilities and taste [as your team], but you can also elevate each other's ideas.'

Max Clark

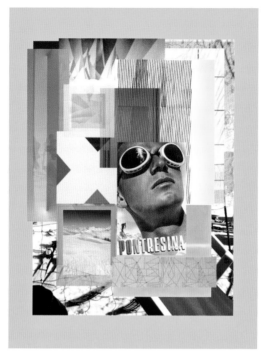

Figure 4.3 **Inspiration moodboard by Anna Latham.**

Sourcing clothing

We have already established that this area is the remit of the fashion stylist. How and where you source clothing will depend on your continued energy, resourcefulness and networking ability. As well as sourcing items for a shoot a stylist will bring a reserve of clothing and accessories, which may be vintage finds from their own wardrobe or pieces that have been amassed over time on previous shoots. Usually they are classic pieces of jewellery or belts, scarves and sunglasses. Basic clothing, such as a plain white T-shirt or shirt, is also good to have. These extra pieces can often fill in the gaps during a shoot where you need, but don't have, another option; an alternative colour or different shape. In addition, the model's own clothes should also be used as a resource. Ask them to bring general items such as jeans, vests and T-shirts, plus any specific items you can think of. Footwear is always difficult to source and if the model has large or very small feet it is helpful if they bring a range of styles to the shoot. While this is a useful option, do not rely on others providing clothes for you.

Figure 4.4 **Clothing and accessories can be sourced from anywhere; how you go about sourcing will depend on your energy and resourcefulness.** Photography: Jacqueline McAssey.

Making contacts

Being a stylist is all about making contacts in fashion and working with designers, PR agencies and retailers. The best place to start is where you live; expand your contacts book by finding fashion designers, jewellery makers, milliners and shoemakers that are local to you. If you are at college then you are probably surrounded by creative students producing a diverse range of clothing and accessories. Tapping into this great resource means you will have access to original clothing that won't have been used or seen before. Sourcing further afield, emerging designers can also be discovered at end-of-year college shows, on social media and online platforms that champion new talent.

Clothing, accessories and footwear brands and designers can also be found at business trade shows, such as Prêt à Porter Paris. Fashion Week events like those in London, New York, Paris and Milan don't generally allow students to attend the fashion shows or exhibitions, although this won't necessarily deter the most resourceful student from gaining access.

Vintage or second-hand clothing

Second-hand shops, car-boot sales, flea markets, fairs and retail websites, such as eBay and Depop, are all great places to find vintage and period clothing and accessories, and they should be relatively inexpensive. The point of sourcing items in this way is not necessarily that you find a rare vintage piece but that you find something that resonates with you, something that fits with the story you are working on and that is, above all else, unique. Specialist vintage shops that sell antique jewellery or original pieces by recognized designers are usually expensive, but it may still be possible to find the genuine article, at the right price, from time to time.

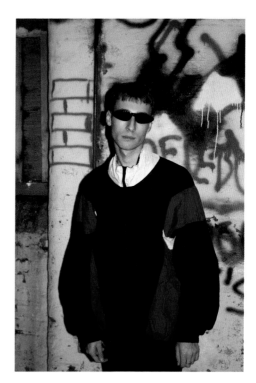

Figure 4.5 Menswear editorial inspired by 90s rave culture. Vintage pieces are used to give the image a sense of authenticity. Photography and styling: Ella Fox.

Family and friends

In a similar way to sourcing in second-hand shops it's always advisable to explore the wardrobes of your friends and family. Consider how many aunts and grandmothers keep hold of their clothes for sentimental reasons or because they haven't got round to sorting through them. Likewise, their antique jewellery can be a welcome, unique addition to your shoot. However, using other people's clothes and jewellery, which are probably irreplaceable, brings responsibility and should be treated as a supplementary source, rather than relied upon.

Buying and returning clothes

As a team you may agree on a small budget for clothing and accessories but this can be used up quite quickly. As sourcing can be difficult when starting out, it is common practice to buy clothes from shops and return them. However, often it's not possible to return certain items of clothing, such as underwear, swimwear or tights. Similarly, earrings are usually non-returnable in most stores. It is up to you to determine the best method for you and your team and remember that the clothing is the responsibility of the stylist: ensure that the store accepts returns and make a note of the terms and conditions; be extremely organized with the packaging and carrier bags and, most importantly, the receipts. Keep receipts in a safe place and make a note of which goes with each item.

Customizing

Customization can mean anything from dyeing clothing to pinning, pleating, folding, cutting and slashing a garment to give it a new look. Reworking items in this manner is a creative way of reinventing a garment and it works well when you use inexpensive, basic pieces. The addition of embroidery, beads, gems or simply drawing on a garment can revamp plain clothing; also consider using transfer paper, which allows you to design and apply your own prints. In addition to haberdashery you could try customizing clothes with items found in hardware stores: wiring, tape, even nuts and bolts can all be used on clothing and in photoshoots. If you have a background in fashion design, pattern cutting or construction, you can approach customization in a different way, such as deconstructing clothing – unpicking seams, removing sleeves and collars – to construct a wholly different outfit, thus creating something unique to shoot.

As the stylist you will be heavily involved in sourcing the props when you are starting out. In the absence of a budget, which would allow you to hire from a prop house, you will have to use your negotiating skills to the full. Being creative is a constant but rewarding challenge. Producing a shoot without a budget will test your creativity but, if you are going to succeed as a stylist, creativity will be your biggest asset.

Figure 4.6 **Painting, dyeing, cutting, sewing, pinning and printing are all simple ways to completely overhaul the look of a garment**. Photography and styling: Daniel Ellison.

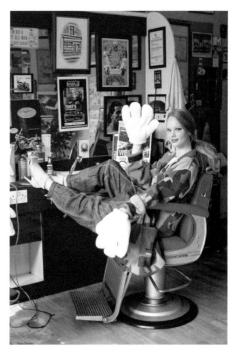

Figure 4.7 **Cartoon-like gloves from a costume shop are used to add a playful feel to this womenswear editorial**. Photography: Lucie Armstrong. Styling: Sophie Benson.

Second-hand props

Second-hand shops, car-boot sales and websites are good sources for imaginative and bizarre props that you would otherwise only find in a prop house. As with clothing, second-hand furniture and props may be sourced and customized. For a small donation, some charity shops (thrift stores) may let you use the furniture and then return it after a shoot. Inexpensive furniture can be painted or distressed to suit your needs. However, you will need to arrange transportation of large items to the studio or location. All manner of homewares and furnishings, such as vases, ornaments and cushions, can be sourced second-hand. Paintings, photographs and frames also give a room set a new look. Everyday items such as magazines, books, flowers and plants are easy to source but often you will need a specific prop for a shoot and this is where your research skills will be put to the test. As mentioned previously, use the internet – websites such as eBay and Depop – to search for even the most obscure props.

Changing a location

Creating a set in a studio could involve painting a wall, laying a floor and moving furniture into the space. Alternatively, as photographs capture a moment in time, it is possible to temporarily change an environment for a shoot and most rooms can be restyled to some degree. By moving or covering furniture and removing pictures from walls you can change the look of the set; wallpaper or backdrop paper can be hung temporarily and fabric can be draped in imaginative ways. When the shoot is over the location can be restored to its original state. Whatever you decide to do, you will probably need the team or an assistant to help you.

Ready-made props

Locating a space containing the perfect props saves a lot of time and is easier than borrowing or hiring expensive props or trying to create a room set inside a studio. For example, shooting in a hotel offers stylists the opportunity of working in modern spaces that are already dressed with high-end products, such as modern lighting and luxury furniture.

Professional shoots are often constructed around the model; certainly in many fashion advertising campaigns the model is as high profile as a celebrity actor or musician. It is likely that you and the photographer will need to agree on the right person for your shoot. It is best practice to meet the model and establish if they have the right attitude and energy, whether that's in person or via video calling; it also allows you to decide on their relevance to the story.

There is always a trade-off involved when using models, whether professional or otherwise. You should supply the model (or agency) with images from the shoot and it's good practice to do this promptly. The team could also agree to contribute to the model's expenses, which could mean paying for travel and lunch.

Figure 4.8 Smiley face props nod to the rave culture that inspired this editorial. Photography: Yanti Walsh. Styling: Megan Carmichael, Caitlin Austin, Yanti Walsh.

Professional models

Most model agencies represent men, women and sometimes children, but the philosophy of modern agencies is quickly shifting towards a more individual focus. Fashion consumers recognized the fashion industry was not being representative and were able to share their opinions on social media, amplifying voices that hadn't been heard before. Campaigns such as All Walks Beyond the Catwalk also brought the lack of diversity to light, challenging the notion that there isn't one body ideal by featuring a 'broader range of sizes, ages and skin tones'. Some agencies began to react by rethinking their representation, extending their talent to include a more diverse array of people. Many model agencies are aiming to democratize the modelling industry by signing more people of colour, people with disabilities and people that don't fit the typical size 10 mould. Personality is also a focus, with activists, musicians, sports people, artists and others now on the books.

Model agencies are businesses, so if you want to use a professional model you will usually have to pay for their services. It is unusual for students to gain access to professional models unless they have a strong portfolio or good contacts with the agency or within the fashion industry. If you don't know the agency they will certainly want to know more about you. They may ask to see examples of your work, and the photographer's work, before considering you. Don't be surprised if your request for a model is turned down. Styling is about making contacts and developing your work, and this improves with experience.

Another way of gaining access to agency models is to work with a 'new face'. These are usually new models who are building their portfolios and require more experience on photoshoots before making it to the main board of an agency. Most modelling agencies feature these models under a 'new face' section on their websites. Using new faces can help you establish a relationship and rapport with model agencies, which is important for your future work.

Street casting

This involves finding people to model for you by approaching them on 'the street', which is a useful way of finding people who are not signed to model agencies and who can model for free, or for travel expenses. The phrase originates from when publications would literally scout people on the street but now covers discovering people on social media too. Consider the type of person you need and where you are more likely to find them; for example, sourcing an athletic model at the gym. By using a street-cast model there is greater scope for finding an alternative look, which may be an important requirement of your shoot brief. Sometimes a shoot idea may stem from someone with an unusual look or a specific skill or talent.

When you have spotted someone suitable, approach them and ascertain if

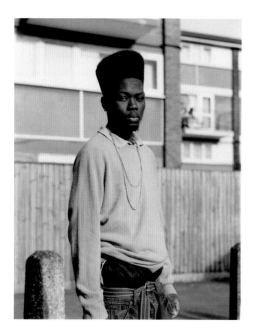

Figure 4.9a, 4.9b and 4.9c 'Locals', a personal project by photographer Jamie Hawkesworth, is an example of a professional photographer's editorial story, influenced by environment and street casting. Photography: Jamie Hawkesworth.

modelling is something they would like to do. Reassure them by giving them a little information about what type of shoot it is. Ask for their contact details, plus information regarding their height, clothes and shoe size (if appropriate) and take a photograph: a head-and-shoulders shot and full-length shot is sufficient. Also, remember to check a potential model's age to ensure they are over eighteen. If, for example, your shoot is based around teen culture and you need a model who is under eighteen, it is imperative that you get parental permission and involvement.

The negatives with using such a person could be their lack of experience but, as you are also looking for experience, it is a good place to start. You could potentially find great people to work with. You may also consider using more than one model to cover all eventualities, such as if your model pulls out at the eleventh hour, which can happen if they are particularly nervous about the shoot.

Scouting online

You can also consider creating a group on social networking sites to aid your search. Groups can be promoted through your social media platforms. This is a good way to make new contacts and can geographically widen the search for potential models; of course, geography has to be taken into account if your model has to travel long distances to the shoot.

Fashion shoots take place both in the studio and on location. The story is crucial in determining if you need a studio or a location but other factors such as weather, equipment and location availability must also be considered; you can only work with what you have at your disposal. If you are a student you may be lucky enough to be able to use a professional, fully equipped studio for free. Otherwise, the location possibilities are endless: imposing spaces, such as cool hotels and grandiose stately homes make great backdrops for shoots, as do more humble settings, such as cafes or launderettes. Location sourcing is now more accessible than ever; it is possible to view locations such as hotels and stately homes online and to see both exteriors and interiors. There are many pros and cons involved in studio and location shoots but, ultimately, it is beneficial to experience both when testing.

'Location has its own atmosphere and will give the image a reference in history, society and geography.'
Alex White

Figure 4.10 **A personal photographic editorial, based on locations, by Jamie Hawkesworth.**
Photography: Jamie Hawkesworth.

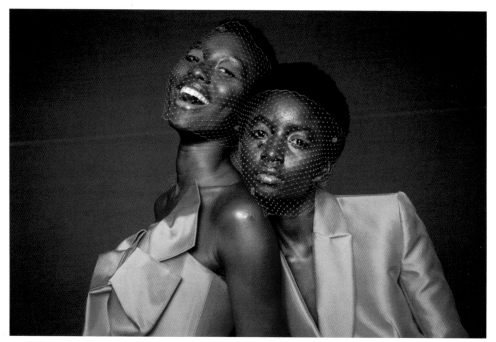

Figure 4.11 **A black studio backdrop allows the bold pink styling to stand out.** Photography: Pablo Cuadra, via Getty Images. Styling: Antonio Burillo and Juan Carlos Fernández.

Locations

Studio

Shooting in a controlled environment means not having to worry about the lighting or weather, as you would if you were outside. College and university studios will normally be equipped with lighting, cameras, computers, backdrop paper and props, and even potentially hair styling equipment, mirrors and clothes rails. Hair and make-up can be done either in or near the studio and models will have somewhere to change clothes in relative comfort. Add some music and it is possible to generate an energetic or relaxing ambience during the shoot.

Using the studio as a blank space, without props or furniture, places the emphasis on the lighting, clothing, model and poses. If you don't have access to a studio then you may want to choose an interior space that resembles a 'blank canvas'.

Figure 4.12 **The intricacies and oddities within people's homes can make for an interesting backdrop for a shoot.** Photography: Hollie Bradbury.

On location

Shooting on location can add colour and glamour, a sense of decay or a feeling of familiarity. If you are open to using any location then consider your surroundings. Take a fresh look at where you live, work or study. An effective location can be as ordinary as your own garden or kitchen. Always take a photograph when you see an inspirational location.

If it's a complete look you want then hotels offer many different types of interior that are fully furnished. If you are looking for a real home to shoot in, then consider approaching an estate agent who may let you use an empty or furnished property or ultra-modern show home.

Another point to remember is how many scenes you want from your shoot. Does the location have enough detail to get the amount of different scenes you want? Open spaces such as parks and woodland offer impressive views and a variety of different settings for one shoot, whereas one small room may be limiting. Shooting outside is also affected by the light so this also has to be considered; the weather is the uncontrollable variant in any outdoor shoot.

The first steps in trying to shoot at a location are simple. Make contact with the relevant person, usually a manager. Explain what you are doing and that the photographs are for your portfolios. Make clear exactly what you need and, more importantly, how long you will need the space for. Locations such as cafes and hotels are working businesses and need to keep running during your shoot; they may suggest a quieter time for you to use the space. The more organized and professional you appear, the more trust and confidence will be placed in you.

A note of caution regarding location work: permission or special permits will most certainly be required when shooting on someone else's property. It may be impossible to shoot in government-owned buildings, places of national importance or in public places, such as swimming pools or train stations. Permission to shoot in open spaces such as parks and beaches may also be required, especially if they are in protected conservation areas. Always do your research; if you don't, you could risk being removed from the location, which will threaten the shoot and waste the team's time and money.

Similarly, derelict properties, with their decaying interiors, are always attractive to stylists and photographers but you must consider the dangers of shooting in or around such a building.

When considering working at a location it is imperative to have a plan B should the weather make it impossible to shoot or if there is a change of plan. When looking at possible locations look around the area for alternative places to move to. If, for instance, you are planning a shoot in a park, look for a covered area you could move to should it rain.

Figure 4.13 **Fashion editorial shot on location in a Victorian swimming baths.** Photography and styling: Martha Weaver.

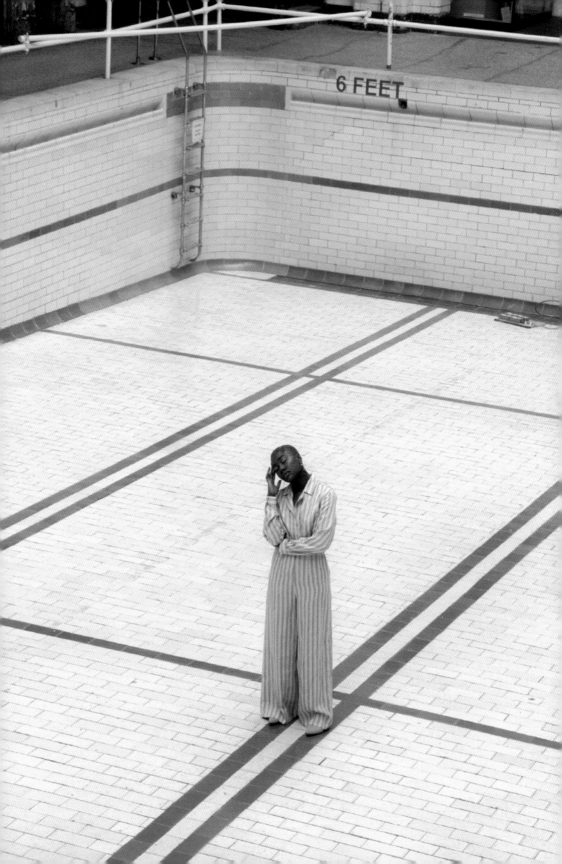

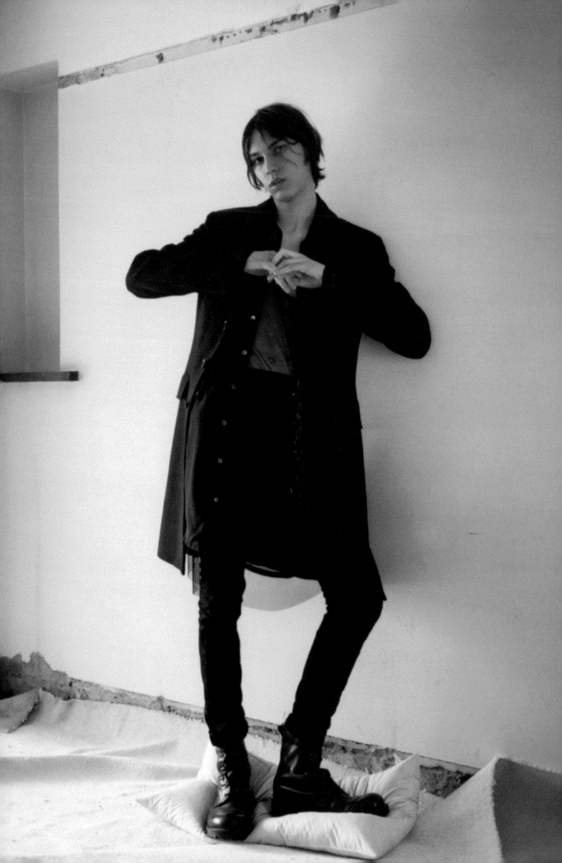

The Photoshoot in Production

5

Production planning

All fashion shoots will need forward planning to ensure the day runs as smoothly as possible. Who takes the role of planning is up to the team to discuss but production can often be split between the photographer and stylist, or another person can be brought on board should the job become too big. Consider the following production challenges:

- First, is everyone available? It can be difficult if the creative team or the model have to squeeze the shoot in alongside studying or work.

- Permission to shoot at a location should be arranged during the production stage. Make sure the team has identification or a letter of authority agreeing that the shoot can take place. Always save correspondence and take it with you.

- Take note of the size of the location, particularly indoor spaces. Logistically, how will the shoot work if there is a large group of people involved?

- Locate electrical points for equipment such as cameras, lighting and laptops.

- Are there any changing facilities for the model? Are there toilets available?

- Think about transport for the creative team, models, clothes, equipment and any props. If you are driving, is car parking available and is it free of charge? Do permits have to be arranged in advance?

Figure 5.1 'Boulevard De Sébastapol', a fashion story for CR Fashion Book. Photography: Andrew Vowles. Styling: Ben Perreira.

'Compressed time leaves no time for dialogue – no time for the kind of alchemy that happens when you make space.'
Venetia Scott

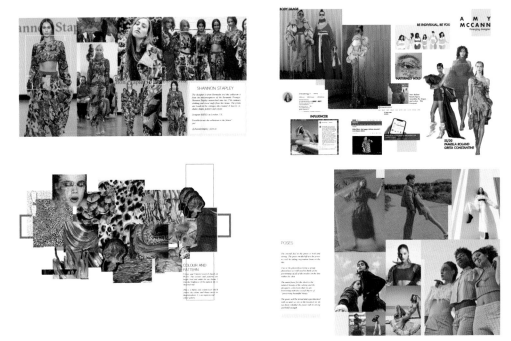

Figure 5.2 **A series of moodboards by Abigail Fairclough, reflecting the many stages of a photoshoot, including inspiration, concept, sourcing, and ideas for poses, colour palettes and make-up.**

Equipment

The type of equipment you will need very much depends on where you are working. A well-equipped studio will have apparatus such as rails, irons and steamers so you won't need to source and transport them to the shoot. If you are going to use a studio that you've not worked in before always check what equipment is there; don't assume it will have everything you need. Shooting on location will be quite different. You may have to bring all relevant equipment with you as well as the clothing and accessories, which can take up a lot of space; it all needs to be methodically organized.

A stylist should have a range of indispensable small items that they can easily transport from job to job, usually in a utility box or bag. If you are an art and design student you will own most of these items already.

A basic styling kit

Essential (these are the things a stylist should always have on a shoot):

- Sewing kit: needles and various colour threads, straight pins, safety pins, scissors, tape measure, stitch unpicker to unpick hems and seams
- Clamps in various sizes, to temporarily adjust garments
- Steam iron or hand-held steamer
- Lint roller or clothes brush to remove unwanted hairs and fibres from clothing
- Masking tape to protect the soles of borrowed shoes
- Double-sided tape to secure or repair hems
- Body tape to keep clothing in place on the skin
- Basic, skin-toned underwear

- Garment bags to protect and organize clothing in transit and during shoot
- Bags or suitcases on wheels to transport clothing, accessories and sundries
- Hangers (particularly if you are on location)

Desirable:

- Ironing board and sleeve board – these should be lightweight and portable
- Invisible nylon thread is good for hanging clothing; it is frequently used in still-life styling and visual merchandising
- Collapsible clothes rail
- Pop-up changing tent
- Dressing gown for the model
- Make-up protector hood
- Vertical clothes steamer (this allows you to steam a greater number of clothes in one go than a hand-held version)

Figure 5.3 **A selection of basic styling equipment, a small hand-held steamer and a steam iron.**

You may decide to invest in more expensive equipment as and when you need it. Vertical garment steamers are easy to use and perfect for garments with an intricate construction or delicate details. They are fitted with large water tanks, which means you can steam clothes for much longer than you would if using a small domestic iron. Professional steamers are expensive; less expensive are the compact or hand-held versions, which hold less water. Garment rails on wheels are ideal for hanging and organizing the clothes before and during a photoshoot. Rails vary in size and cost; it is possible to buy domestic-use rails from high street stores or sturdier professional rails from fashion retail suppliers. Ideally any rails you use should be collapsible or break down easily to fit into a car should you have to take it on location.

Photographic equipment is really the concern of the photographer. Along with cameras and lighting they may want different types of lens, reflectors, ladders and so on. If you are lucky, your photographer will own some or all of the kit needed. If not, equipment can be borrowed from friends or a college store or rented from a camera hire shop. If you are shooting outdoors or in a space that doesn't have electricity then you will also need battery packs to power the equipment. Again, the photographer will establish this.

If all this equipment has to be moved to location then arranging reliable transport is crucial, as is the security of such items. Never leave valuable equipment on show or unattended in cars or in public locations. If it's not possible to keep it all with you, assign an assistant to watch over it during the shoot.

It is imperative to communicate with the team before the shoot in order to consolidate ideas. Pre-shoot communication, whether in person, via email or group chat, should leave everyone with a clear outline of the story and the day itself.

It is also useful, particularly for the photographer, to undertake photographic tests in preparation for the final shoot. A friend or assistant, if the model isn't available, can assume the role of the model, standing in the location or studio space as the model would. The photographer will then do a series of test shots, arranging the lights in order to achieve the desired effect and working out a plan for the day. If both the model and the clothes are available then it is possible to do a full mock shoot, where all ideas can be put into practice, knowing changes can still be made. The mock images may then be reviewed by the team and any alterations suggested for clothes, make-up, lighting and location before the final shoot.

Figure 5.4 **Testing the effects of a kaleidoscopic lens filter for a photoshoot.** Photography: Carly Young. Styling: Carly Young, Martha Weaver, Martha Hollingsworth.

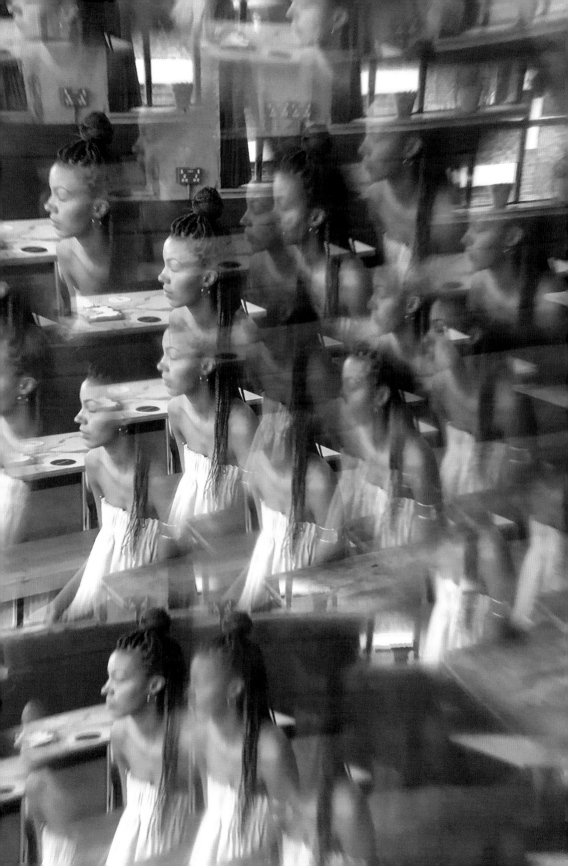

Final brief and testing

Call sheet

The photoshoot is a complex production and brings together a number of people, clothing, props and equipment; in order to synchronize all these elements a call sheet should be used. A call sheet provides details of the talent and creative team, including assistants; their names and roles on the shoot, along with their contact details. The document will also specify a 'call time', which is when the shoot begins, the location and address, transport details, maybe a map of the location, weather forecast and any catering details.

To aid time management it should also act as a timetable, showing the shoot broken down into practical time frames; if, for example, ten shots are required, this equates to five in the morning and five in the afternoon. This keeps the team on track during the event. Special requirements are also recorded on the call sheet, such as, for example, 'Can model please bring black workwear boots'. The document should then be emailed to each member of the team a day or two in advance of the shoot.

It is a professional mode of working and makes perfect sense when trying to get everyone and everything to the right place at the right time. For instance, if a member of the crew is running late or finds that they are lost on the way to the location they can refer to the address or map on the call sheet or call a member of the team for further directions.

Call sheet for 'Paint the Planet' shoot

Location 1/meeting point, 9am–2pm: Roots Collective Artist Studios Location 2, 2pm–8pm: Community roof garden	Shoot date: 25th October Call time: 9 am Wrap time: 8 pm
Contact (production): Clare Buckle [A phone number will usually be supplied]	
Photographer: Priya Khatri	
Photo assistant: Henry Doyle	
Stylist: Marsha Cole	
Stylist assistant: Adam Hinks	
Models: Amadine, Julie, Coco	
Model chaperones: Danielle Bone and Kirsty Geddes	
Hairstylist: Martyn Jones	
Make-up: Jurgen Gregory	
Catering: Clare Buckley and the production team will supply food and drinks. Must include vegan and nut-free options	

Day schedule:

9 am: team arrive at studio

9.15 am–10.30 am: hair and make-up, shoot set-up, styling prep

10.30 am: shoot begins, shots 1–5

1 pm: wrap first location, lunch for all crew

2 pm–3 pm: crew clean up, pack studio, move to second location

3 pm: shots 5–10

7–8 pm: wrap second location, crew clean up and pack

Interview

Laura Holmes

Laura Holmes is the founder of Holmes Production. Her clients include adidas, Gucci and *Self Service Magazine*.

Figure 5.5 Laura Holmes's website showcases a selection of her best and most recent work.

What is production and how do you spend your average working day?

Production is making it all happen and/or finding the right people and making sure they have the right tools to do so – on brief, on brand, on budget and in time. It's anticipating, planning, problem solving, persuading, wrangling, predicting and managing the whims of often unpredictable ambitious creative teams.

Days are never average but can involve:

- talking to the client or to the director or photographer about the brief

- discussing their approach, research locations, visiting a chosen location to preempt requirements both creatively and logistically

- finding and booking the right creative team and equipment and negotiating rates with agents or suppliers

- attending a pre-production meeting with a client, drafting budgets, briefing artists

- supervising a prelight or a build or a shoot

- sitting in on a post-production session and many more things besides!

What is the stylist's role within the creative teams you work with? For example, does team selection start with the stylist: do clients like to work with the same teams?

Clients often like to work with the same team if a shoot or event has been successful. Selection can either begin with the photographer or director, or with the stylist. Many fashion brands start with their stylist as they may also have a larger role with the brand consulting or working with them on their shows. The stylist can be booked seasonally for a number of days for a brand or purely for a particular shoot. Preparation can vary from many days of preparing looks and overseeing fittings to a small amount of shopping and the shoot itself. The stylist often has a large say in the hair and make-up team that are booked and also the casting selection.

How do aspiring stylists find new work? Is it important to have a physical or digital portfolio or is a social media presence sufficient?

Of course, new work attracts new work but I think it's important to have a portfolio of selected work that best represents the talent. For a stylist I think this can be on a tablet rather than a physical book. Social media is increasingly important and brands often look at this first now, even negotiating branded posts into fee contracts.

What do you think the future of image-making will look like – have you noticed any significant changes in the last few years?

There was a massive trend over the past few years for photography shot on film using traditional methods, most likely as a backlash to camera phones and digital cameras being so readily available. Perhaps things will go the other way again and the trend will become the embracing and advancing of digital technology.

Over the past few years the demand has grown for *more* content – clients want more than just a handful of strong campaign images, they also want video content, GIFs for social media and behind-the-scenes (BTS) which brings with it a host of challenges.

The challenges are threefold: creativity, money and time. Creatively, in that it's always a challenge to produce good images, let alone lots of them. Financially, as more content means more overtime and more post-production. Time, as more time isn't necessarily always possible, making more content in the same amount of time means less time for everything and so more pressure on all involved.

With our exposure to more imagery than ever, it's never been more important to ensure that the imagery we create connects with people in some way.

Interview

India Harris

India Harris is a freelance creative producer. She has produced campaigns for Hypebeast, Nike and Soccerbible.

How would you describe your practice?
I would describe being a producer as someone who pulls everything together. They are the structure and glue that makes and delivers a campaign or photoshoot. I would best describe myself as a creative producer because I am usually briefed by brands and agencies to create content or campaigns. Being a producer means bringing an idea to life and making them tangible. Sometimes I produce campaigns, this can be anything from locations, casting, commissioning teams of film or stills crew (lighting, assistants, art directors), managing budgets, logistics and catering.

What did you study and did it have an impact on you becoming a producer?
I studied Textile Design with Business Studies specializing in printed textiles and I also interned as a screen printer and print designer. Being a producer means you have to be very motivated, organized and efficient with time and these are all traits I developed and finessed whilst balancing my workload at university. Although working as a producer is seemingly unconnected to textile design, I learnt so many transferable skills on my course that I use daily as a producer. For our degree show my fellow students and I had to organize a photoshoot and presentation for Graduate Fashion Week. I took the lead on organizing the shoot and creating schedules for our shows. I chose to do this because I knew I was good at organization and leading people – before I knew what being a producer meant.

What skills do you need to become a successful producer?
Production is a puzzle – it's putting together all the pieces and making sure that everything is where it needs to be. It's about being very organized, building strong relationships with people and having excellent communication skills. If you don't have this then everything falls apart. Being calm and collected in stressful situations and problem solving are also key to being successful. I have stood in torrential rain with clients and crew frantically stressing about what we can do to save a shoot. In these situations, staying calm, thinking rationally and retaining good energy and morale is so important for achieving good results.

As a recent graduate how important is it to have a digital portfolio and a social media presence?
Digital is so important, even if you struggle to keep platforms up to date just having an online presence is so crucial. It's a snapshot of who you are and what you do and gives a good impression. In my whole time being freelance I have never once been asked for a physical portfolio but I am asked on an almost daily basis, 'What's your Instagram?' However, I have never relied on a website or social media to get work. I thoroughly believe that word of mouth and making a lasting impression is the most powerful tool but I do rely on my social profile to discover new talent and creatives.

Figure 5.6 India Harris uses Instagram as a visual portfolio for her work.

What do you think the future of production will look like – have you noticed any changes in the last few years?
I have noticed that brands are going directly to freelance producers rather than production companies. The new wave of freelancers are not bound by guidelines. When you have your name and reputation to fight for, you work to a high standard. The more you put in, the more you get out.

Diana Vreeland (1903–1989)

Diana Vreeland was a magazine editor and fashion icon. She reinvented the job of fashion editor at *Harper's Bazaar*, where she worked for over twenty-five years: she chose the clothes and oversaw the photography. She went on to become Editor-in-Chief at *Vogue* and then consultant to the Costume Institute of the Metropolitan Museum of Art.

'[Diana Vreeland] was and remains the only genius fashion editor.'
Richard Avedon

Editing the clothes

The process of selecting and editing clothes is probably the most exciting part of the fashion stylist's role. Preparation and organization are key; the more time you have with clothes beforehand, the more you can experiment with the looks and perfect your ideas. Editing prior to a shoot can also help determine if something won't work or if alternative items have to be found. Unfortunately, however, it is not uncommon for borrowed clothes to arrive the day or night before a shoot or even on the day itself, particularly if they've been sourced from local designers or retailers. Similarly, if you have asked the model to bring clothes to the shoot you might not see them until they arrive on the day. Stylists often work with clothes that they have not seen close up, if at all, and the ability to think on your feet constitutes a major part of the stylist's qualities.

When you take delivery of the clothing, make a detailed list of what has been borrowed and where it is from. Unpack all the clothing and hang it on rails or on a clean floor. Start the editing process by putting ideas of looks together, keeping the shoot story in mind. Then try each outfit on the model or a friend or even

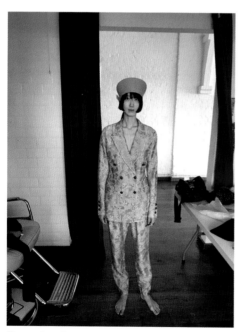
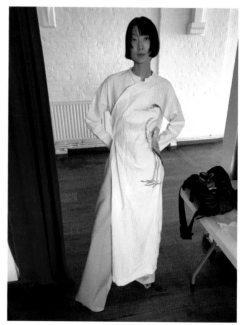

Figure 5.7 **A model tries on looks during a fitting, which helps the stylist decide which garments and accessories to put together.** Photography: Megan Mandeville.

yourself; clothing looks different when worn on the body. Fully accessorize your choices with jewellery, shoes and hosiery. Finally, take a photograph of each option, not only to remind yourself but also to show the team on the day of the shoot.

The more prepared you are, the more creative you can be on the shoot. Looks can change when placed in the environment and what you originally envisaged may not work. Edit clothes that are not right, but do make sure you take alternatives to help your styling on the day. Finally, all clothes should be pressed, placed on hangers and in garment bags, ready to transport to the location.

Day of the shoot

As a key member of the photoshoot the stylist has to work hard to ensure that it runs as smoothly as possible. A shoot can descend into chaos quite easily as more people arrive and their bags and coats are removed and clothes and equipment are unloaded. Follow studio etiquette at all times; this means abiding by the studio or location rules. Food or drink is not usually allowed in studios. Shoes should not be worn when walking on paper backdrops, so work barefoot or wear socks. Also, be prepared for bad weather in outdoor locations; take waterproofs, blankets and hot drinks in flasks to ensure the model is warm and comfortable.

Hair and make-up usually take longer than expected so the earlier you can start the better. Where possible find a space to arrange clothes, accessories and shoes, on rails or tables. Try to arrange everything so you can see it all; you can easily forget about what you have sourced. Check the clothes and assess those that need further steaming. Place the clothes in

order and arrange the accessories that go with each outfit. If you have time, check the fit of the clothes on the model, particularly if there has been no previous opportunity for a fitting; otherwise you can do this quickly in between shots.

Working with the photographer and model

Discuss with the team the look you are shooting first and dress the model. The model will stand in the space and the photographer will start shooting to determine if the lighting and camera settings are correct. When the photographer is ready to start, you can make final adjustments to the clothes. By clamping or pinning the clothes at the back you can alter the silhouette of the garment, drawing it in at the waist or hips. Be sure to tell the model what your role is; what it entails and that it is you, as the stylist, who modifies the clothes. It is common for new models to try to adjust the clothes themselves, which can be annoying if they are in a perfect position or if it has taken time to help them master a pose.

Standing behind the photographer allows you to see what they see. If the photographer notices a problem with the clothes and asks you to amend them, you will know instantly what they are referring to because your positioning and eye line will be the same as theirs. Standing behind also means you won't get in the photographer's way or in the shot! If you need to enter the set to alter the clothes then say so and the photographer will wait until you have finished before shooting again. Occasionally a styling idea may not work as you have envisaged it, so move on and try another idea and something more interesting may take its place.

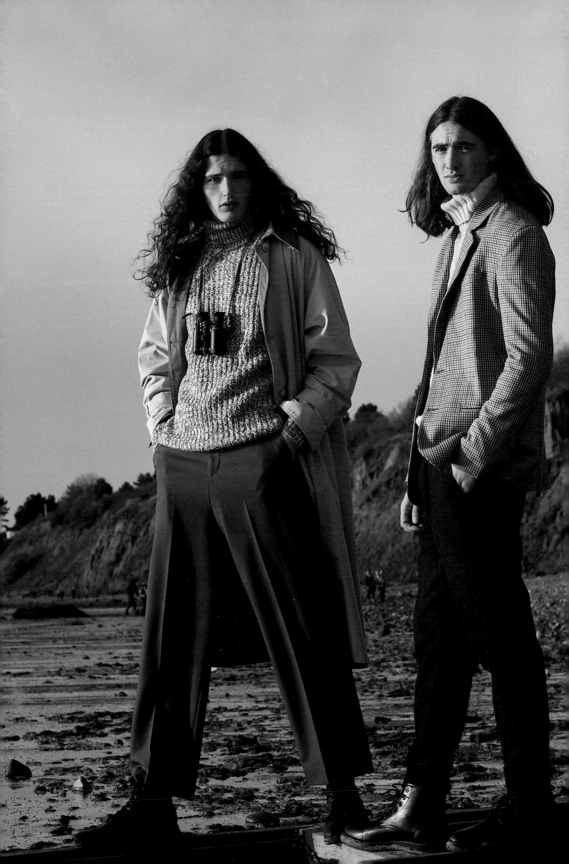

As the shoot progresses the photographer should show a selection of the best shots on a computer so the team can see the story developing. The looks prepared towards the end of the day might change a little as you react to the first combination of shots. For example, if you have lots of good full-length shots the team may decide to focus on a close-up shot of the model's head and shoulders. This may change what you have planned for the remaining photographs. A head shot will exclude clothes and shoes being worn on the model's lower half and you may want to add jewellery, a collar or hat or rethink the make-up and hair as it now forms a prominent part of the image.

Figure 5.9 **A model takes different poses to show different angles of a dress.** Photography and styling: Lauren Roberts.

Figure 5.8 (facing page) **Menswear editorial set on the shoreline at sunset.** Photography: Lyn Dizon. Styling: Isobelle Binns.

Clothing care

The clothes are solely the responsibility of the stylist; taking care of them is your job before, during and after the shoot. Keep clothes organized and tidy as you work. If you have an assistant make sure that they pack away things that aren't needed; putting clothes back on original hangers, shoes in boxes and repackaging items with tissue or tags. Managing the clothing in this way means that there will be less to do when the shoot is finished.

This could be critical if you have a narrow window in which to shoot, pack up and leave a location.

When the shoot is over any borrowed clothes should be returned in their original packaging, ideally the following day. It is extremely bad practice to hold on to clothes and if you do this it will jeopardize your ability to borrow from the same source again. Make a list of the items being returned, when and by whom.

Figure 5.10 **Shoes are placed carefully on top of a dust bag in order to avoid marks or scratches.** Photography: Nicky Sims via Getty Images.

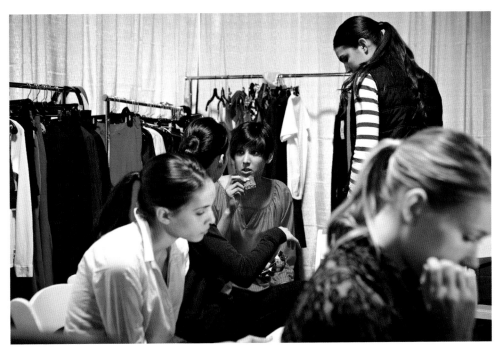

Figure 5.11 **Models relaxing together between shots.** Photography: Thomas Barwick via Getty Images.

Working to your test brief

With so many creative minds involved in one shoot, it is entirely plausible that the team gets carried away with things, spending too long on one shot. Try to stick to the brief and refer to the call sheet to move the process on. Always try to work to the number of photos you need and if you have time at the end of the day you can experiment further. Finally, keep to the agreed times when working at a studio or location space; on a professional shoot you would certainly be charged for going over your allotted time.

Looking after the model

Inexperienced models may feel awkward, shy or apprehensive. You should brief them thoroughly about your ideas and work with them to develop the kind of character you want them to portray. Direction can come from both the stylist and photographer during a fashion shoot; giving the model thorough advice on mood, pose and facial expression. Showing a model how to move means you might have to demonstrate it first and could involve running or jumping, or creating tricky shapes and poses. Models occasionally have to maintain shapes for long periods of time. Be aware of what you are asking for and how long the model has been working, giving them regular breaks, but without compromising the brief or shoot schedule.

Catering

When the team breaks for lunch and the shoot is running on time, it is better for everyone to eat together and at the same time. This allows the team to stop what they are doing, 'down tools' and relax for a short time. It's also quite difficult for a model wearing make-up and expensive or restrictive clothing to actually eat and drink, so it's better to have a clean break. Of course, this assumes that the shoot is not running late and you are sticking to the times laid out on the call sheet. If the shoot is falling behind and you need to make up time then use your initiative.

Always respect your environment and clean up after the shoot. This could entail sweeping floors, cleaning tables and emptying bins. The shoot is not over until this is complete and the whole team should help in leaving the space as it was found.

Editing is one of the most important parts of the entire shoot process and should be given careful consideration and time. Image selection is a varied practice and depends on the stylist's relationship with the photographer. Some fashion stylists/editors work closely with the art directors and the final selection of shots. On a commercial job the stylist may not have any say in the editing process as the client will take over this role, bringing in an art director, graphic designer and so

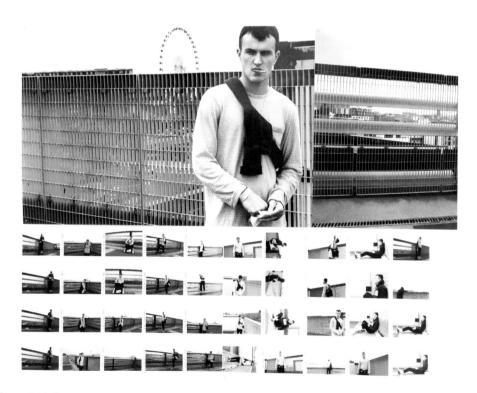

Figure 5.12 Contact sheet of images from a fashion editorial shoot pinned to the wall for selection and editing.

on. On a test shoot, however, you can all contribute to the selection and editing of photographs and it's best to tackle editing as soon as possible. Agree with the photographer before the shoot about when and how you can do this and try to work to the set deadlines.

Image selection

In a test shoot where a more collaborative approach is taken, opinions differ depending on the team's personal tastes. In this instance, the stylist should have a large input into the editing of the final pictures. You could possibly go through all the photos with the photographer or allow them to edit some of the photos and then decide together which works best. Ideally the photographer will look through all of the images and edit down to a selection of the best (maybe five or ten) of each shot. Image selection can be a difficult, time-consuming process; hundreds or thousands of photographs may have been taken during a shoot.

Consider the mood, energy and the model's poses and expressions according to the original story idea. There are obvious mistakes to look out for when editing that can't be rectified in post-production, such as shots where the flash has failed or a model has closed eyes. These shots can be ruled out immediately. When the team is happy with the final selection you can experiment with them; arranging images into a story, taking into account how the images fit together and flow.

Post-production techniques involve enhancing and transforming images using software such as Adobe Photoshop. As with the picture editing process, the photographer is usually responsible for digitally manipulating the photographs

although stylists and most art and design students have a good grasp of the software. Manipulation of photographs can take numerous forms. There are endless possibilities when considering digital editing techniques. The model can be removed from the original location and dropped into another scene, their hair and eye colour can be changed or a photograph converted into a collage. If the photographer is assigned to edit test shoot images the team can discuss what type of editing, and how much, is best for the story.

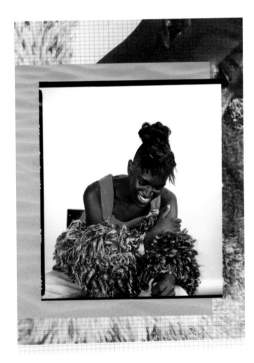

Figure 5.13 Two editorial images are collaged together using a mixture of physical and digital techniques. Photography: Lucie Armstrong. Styling and collage: Sophie Benson.

Photo manipulation and retouching

It is possible to alter the whole image in a basic way by varying brightness, changing the contrast of light and dark and de-saturating it (removing colour, which converts it to black and white). Images will then be 'cleaned up' by removing imperfections such as marks on the backdrop paper or the stylist's hand in the shot. At this point the model's hair and skin can be altered if appropriate for the story by removing spots; dark circles under the eyes that still show through the make-up or a stray hair across the face.

While retouching is still rife in the fashion industry, an emerging set of creatives are rejecting traditional notions of beauty, and brands are following suit. Unretouched images are increasingly commonplace, replacing artificial and unattainable imagery with a more authentic, natural approach.

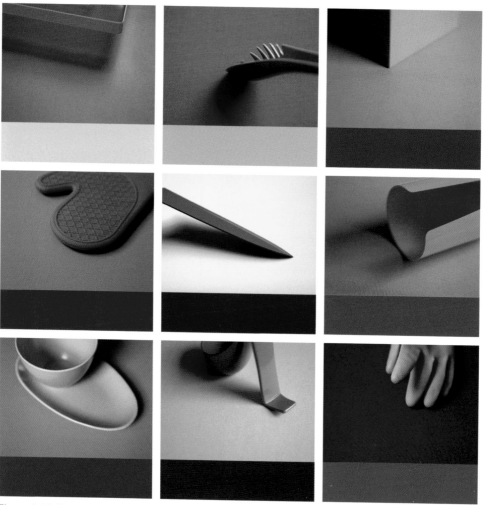

Figure 5.14 **A selection of still-life images are laid out in a grid to emphasize the bold colour contrasts. Key tones are picked out and added as graphic blocks, creating an effect that's reminiscent of colour cards.** Photography, styling and design: Marc Provins.

Layout

If a shoot is commissioned for a publication, layout will often be decided by the in-house art director rather than the original shoot team. However, where a test shoot is concerned, the layout stage of the process provides you with an opportunity to practise your creative technique. Experiment with straightforward or creative crops; repeat or collage the images, both digitally and by hand. Design a fashion editorial by cropping and formatting the images into a fashion magazine layout, with a title, text and graphics. Arrange the images to resemble a lookbook, complete with clothing descriptions, or a promotional advertisement with a fashion logo. Alternatively, it is perfectly acceptable for photographs to be printed and simply displayed in a portfolio without any special layouts. Taking into account personal preferences, image layout may be approached quite differently by the stylist and other team members.

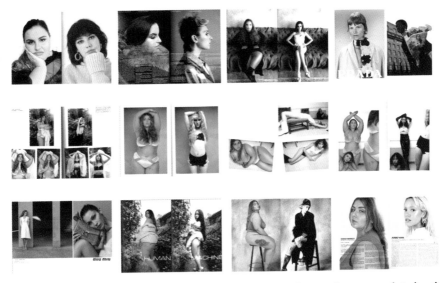

Figure 5.15 A series of magazine layout mock-ups featuring a mixture of re-appropriated and original imagery. Photography and styling: Tia Millington.

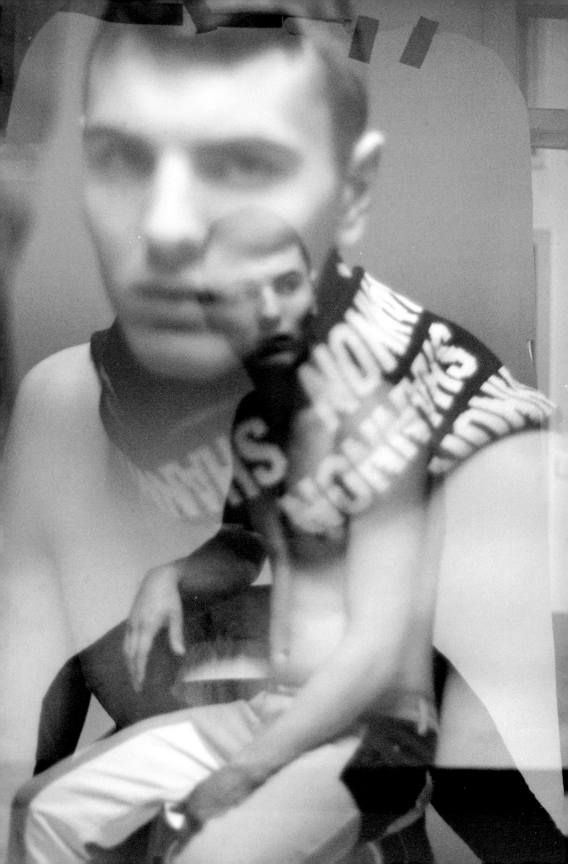

Becoming a Stylist

Styling is a coveted and competitive industry and in this section you will find practical advice on creating a portfolio, building a website, promoting yourself via social media, assisting and interning, and the career options available from freelancing to working in-house.

Collating a portfolio

What should you include in a portfolio? It should communicate a thought process, it should be original and above all it should showcase your best work. This means that you should be selective about the content. You don't have to include every piece of work you have produced. Being able to edit your own work is as important as editing a rail of clothes.

As you have read in this book, there can be differing views about portfolio styles and formats. Traditionally a portfolio would have been a book with clear sleeves which displayed a stylist's photographs in a clear sequence, much like a fashion story in a magazine. Now, however, there are multiple ways to show your work: in a physical print portfolio or book, or digitally via a tablet, or on a website or social media platform such as Instagram.

Producing a print portfolio or book usually means there will be some costs involved and will also involve you committing to a selection of work. At this stage it may be your personal choice to print your work as you may have a preference for a particular size or paper finish. Creating a digital portfolio means you can change the selection or sequence of images quite easily. There are also minimal costs involved as you won't need to print the work.

Figure 6.1 (facing page) Campaign images for menswear brand Christopher Shannon. Photography and styling: Christopher Shannon.

139

Figure 6.2 **A series of portfolio spreads showcasing a variety of different styles of work, by Lauren Roberts.**

Through the process of studying styling, assisting or testing you may have a clear idea about what type of employment you are aiming for and this will probably be reflected in a portfolio that has a distinct content and style. Alternatively a portfolio which demonstrates a range of ideas for different audiences may be beneficial if you are unsure of which route to take. As with a CV you should always tailor your portfolio for a specific person or company by re-editing the content and layout.

Creating a website

A stylist's website should function as an online portfolio; a place where prospective clients and collaborators can view your work, become familiar with your style and ascertain what level of experience you have. While social media is an effective way to share your work with a wide audience in a more informal way, a website acts as a more professional platform and is an important promotional tool for both new and established stylists. It's not necessary to have a huge selection of shoots to choose from in order to create a website; just a few creative test shoots can be enough to generate a professional looking online portfolio.

What to include

A professional website should include:

- A selection of images which showcase your style and versatility
- Information about you, including where you're based, what sort of styling work you undertake and what experience you have
- Contact information

You may also add film or GIFs and, as you gain more experience, it can be useful to include a list of commercial clients or publications that you have worked for in order to demonstrate your experience.

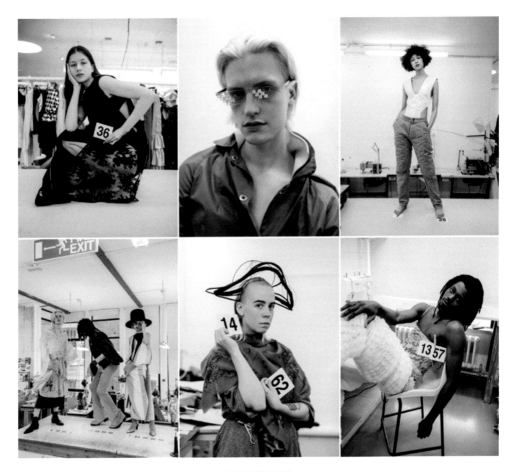

STYLING BY CHANCE
Royal College of Art

Figure 6.3 Masha Mombelli's website makes use of striking 'hero' images to draw potential clients and collaborators in to view more.

Building a website

If you have never created a website before, there are many website builders available which provide templates that make it easy to upload images and fill in your information without having to worry about design or format. Choosing a simple layout will allow your styling to take centre stage without any distractions. Remember, the main focus should be the quality and creativity of your work.

Those with more experience in creating websites may choose to build their own from scratch. Alternatively, a web designer can work to a brief in order to build a website to your specifications. This is usually the most expensive option, however.

Selecting images

While it can be tempting to add as many images as possible to a website, having fewer, stronger images will give the best impression as well as demonstrating an ability to edit your own work. Images should be whittled down to only the very best selection in order to showcase your strongest styling work.

Consider the details. Are the clothes presented well without any creases or pulls? Does the model's pose show off the outfit to its best potential? Is the image framed well? Do the images you have chosen work well together as a set or story? Taking the time to choose your images carefully is an important part of editing and presenting your work.

As well as choosing the best images, it's important that they are properly formatted too. This means making them the right size and file type. Sometimes a photographer will mark images as 'low res' or 'web-ready' in order to note which ones are correctly formatted for uploading to a website. If this isn't the case, you can request images in a web-ready format or use software such as Photoshop to do it yourself. If you are unsure of what dimensions or settings to use, check the information provided by your website builder or ask your web designer.

Self-promotion

Promoting oneself to potential collaborators and employers has never been easier. Social media platforms allow you to share your work, personality and ethos to a potentially global audience. With respect to which content is appropriate to post on social media the advice has changed considerably in recent years. Where once it was uncommon to include personal information alongside examples of work, now it is encouraged. Showing your interests, references, test shoots or behind-the-scenes (BTS) content can give a viewer insight into your personal brand – particularly relevant if you want to work as a freelance stylist.

However, there is often an etiquette involved when posting images and information on social media when working for

Figure 6.4 **This lookbook image for sustainable brand NEMCEE has the model placed in the centre of the frame, showcases the detail and craftsmanship of the clothes and communicates the laidback nature of the brand.** Photography: Ryan Yates. Styling: Niamh Carr.

brands or publications or with creative teams. Always check before releasing information. There could be an embargo in place; for example, campaign imagery may not be allowed in the public domain until a campaign has officially launched, or a photographer does not want imagery posted until images are edited.

Spend time writing a professional and engaging biography for your social media accounts. You may have taken a long time curating visual content but also ensure written content and captions are interesting, free of mistakes and credit people involved in the creation of the work.

Places to work

Finding employment as a stylist, like most jobs, depends on your experience. If you are studying at college or university you may have already started interning or assisting a stylist. Interning offers more than just experience; it is an opportunity to work in a range of roles, departments or organizations, to practise subject-specific skills in styling and improve your transferable skills such as team work, time management and problem solving.

As we have explored earlier in the book, there are a wide range of sectors within styling. Look for entry level positions with specific brands, publications or photographic studios or through employment sites. If you haven't had the opportunity to intern with a company or assist a stylist, you may want to expand your knowledge of the fashion industry which might involve working at a PR or production agency or even in retail as a visual merchandiser. All experience is useful and often the best image-makers have an excellent understanding of the whole industry, not just their specific place within it.

Figure 6.5 Ibrahim Kamara and Cassie Anderson have very different creative styles but both successfully make use of Instagram as a platform to showcase and share their creative work.

Figure 6.6 A model poses for an in-store photoshoot. Photography: Indie Kelly.

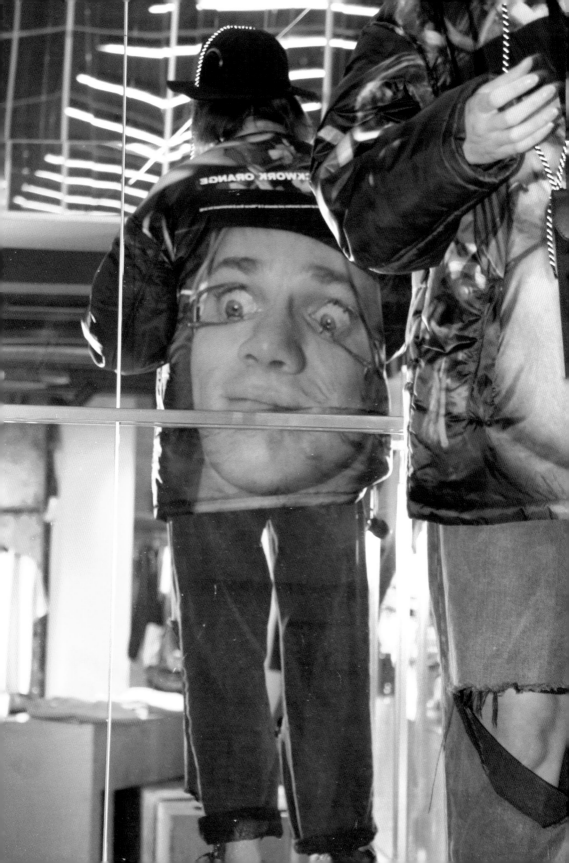

Interning and assisting

Experience is crucial for breaking into styling; a brand or client will need to trust that you know the ins and outs of shoot planning, sourcing, prep, dressing and the many other aspects of styling. It can be difficult to secure a position as a stylist without the relevant experience, so both interning and assisting offer a great opportunity to gain it without necessarily needing any prior job history or qualifications. It allows you to watch how professionals work, acquire practical skills, learn shoot etiquette and meet prospective clients, employers and creative collaborators.

What's the difference?

Although there may be some crossover between interning and assisting, there are some key differences. An internship generally refers to a set period of work experience under a single organization. This could be a magazine, a media platform, a fashion brand or a production studio, for example. While an intern, you will have the opportunity to shadow established members of staff, as well as carrying out tasks which will give you valuable insight into how an organization works and what certain job roles entail. Some of the work involved may be simple, such as answering emails or steaming garments; however, it is important to undertake these with enthusiasm in order to show that you are capable of handling further responsibilities. It's not unusual to find that fashion editors and head stylists also began their careers in a similar way. Even the seemingly little tasks are an important part of a larger machine and shouldn't be overlooked.

While some internships pay or cover travel costs many do not, so it's important

Figure 6.7 Editorial shoots like this require a varied skillset, from casting and location scouting to sourcing clothes, editing looks and directing models. Photography and styling: Ryan Rogers-Hinks.

to factor this into your decision when applying and accepting. An internship can last from a few weeks to many months depending on what an organization offers, and you may have to work part-time alongside your internship to support yourself.

Assisting can be a less formal arrangement as you may assist more than one person or perhaps assist a freelance stylist who doesn't work a standard Monday to Friday week. You may secure a set period as an assistant; however, usually it will work on a job-to-job basis depending on the needs of the stylist. It's important, then, to be flexible and available on short notice, where possible. As with internships, assisting is often unpaid but you can gain invaluable experience in an array of different settings from editorial shoots and commercial campaigns to fashion shows. The role of an assistant can include everything from collecting clothes from designers and PRs and then making returns, to prepping and steaming, sourcing props, answering emails, helping carry kit on shoot days, picking up food and drink for the team, and dressing models.

Whether interning or assisting, act professionally and be as helpful as possible. Contacts are crucial for career development and, if you come across positively, you may well be called on again for future projects, shoots or even job openings.

Finding opportunities

There are many ways to discover interning and assisting opportunities. As internships often take on a more formalized format, they are frequently advertised alongside jobs. Make a list of publications, studios, brands and companies you would like to work for and check through their careers or jobs pages to see what is available. Often, once you find an internship advertised, it's a similar process to job application;

sending a CV, filling in an application form and discussing why you would be right for the role. While you would be expected to have professional experience for a job, it's not necessary for an internship, so you may be invited to talk about your personal experience, education and interests to assess whether you are the right person for the role. In this case, be enthusiastic about what sets you apart. Have you styled test shoots or helped organize a university fashion show? Do you write a fashion zine or blog? All such things can help you to stand out from the thousands of other students or graduates who may be applying.

Obtaining some assisting roles may follow the same formalized process; however, it is also good practice to reach out to stylists and creatives you admire to offer your assisting services, as many simply do not have the time or resources to post job listings. This can be done via email or even by social media; however, remember to remain professional. Explain why you would like to assist them and how you can be of help. Stylists often need assistants at short notice, and taking the initiative to get in touch can be the key to getting noticed and gaining crucial experience.

If you cannot find internship openings at a particular company, a similarly speculative approach can also work. A well-crafted, creative CV, cover letter or portfolio could catch the attention of an editor or manager, who may then reach out when an opportunity becomes available.

When meeting new people, whether for an assisting job or an interview, always be mindful of your own safety, particularly when it's an individual you have only communicated with online. Take a friend or family member who can see you to a meeting safely, speak to other people who may have worked with them and suggest a meeting place you are comfortable with.

Varied experience

When applying for assisting roles or internships, be open to all experience; the broader the set of skills you have the better. Experience on a high-budget editorial shoot can be invaluable but so too can time in a busy commercial studio. Helping with a college fashion show will give you vital experience with dressing models, organizing and prepping garments, just as window dressing in a shop helps develop your eye for still-life styling.

Exploit any opportunity to develop your skills, whether that's offering to help dress mannequins in a store you work at or styling flat lays for a charity shop Instagram account. Once you are open to developing your skill set in as many ways as possible, you may be surprised to find just how many opportunities there are to do so. Equally, contacts can come from many sources too. Volunteering at a charity shop may provide a useful source for vintage clothes in the future, for instance, while a designer giving an industry talk at college could develop into a client or a future collaborator. It's important to be aware of opportunities in many different forms.

Testing

Testing should also not be overlooked as a fantastic way to gain experience. Not only does it allow you to experiment creatively and build up a portfolio, but it expands your network of contacts. A make-up artist you work with on a test shoot may well

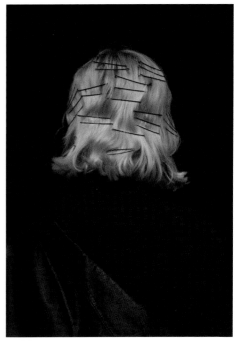

Figure 6.9 **Testing allows you to trial outfits as well as hair and make-up ideas.** Photography: Indie Kelly.

recommend you for a freelance job a few months later, so place importance on the people you collaborate with and reach out to new people who may be able to offer different perspectives or insight.

Figure 6.8 **Opportunities can be found in many places. This image was taken as part of a collaboration with an independent creative retail space.** Photography: Kate Davies.

Working as a freelance stylist

Rather than working for a specific company, brand or publication, a freelance stylist is self-employed. They have the ability to choose whom to work with and what days to work on. Being freelance often means you can work for a wider selection of people on a wider range of projects, which appeals to those who want more variety in their working life. From editorial photoshoots and brand campaigns to TV adverts and e-commerce, a freelance stylist has the opportunity to work on a wide variety of jobs and creative projects.

A freelance stylist must be able to manage their own schedule, negotiate fees and payment and liaise with many clients, creative teams, PRs and designers at one time. It's also very important that a freelance stylist be flexible, as schedules can change frequently and new jobs can come in with as little as a few hours' notice.

Building contacts

While working freelance can give you greater freedom and allows you to gain broad experience, you must also generate all of your own work, which can be difficult, particularly when you are just starting out. As such, building up a network of contacts is very important for a freelance stylist. Contacts can be people you have worked with previously, fellow stylists, fashion editors and other creatives such as make-up artists and set designers. It's not uncommon for a photographer or producer you have worked with previously, for example, to recommend you for another job, so it's crucial to make a good impression and maintain a positive working relationship with as many people as possible.

Those who are new to styling may not have a list of contacts ready to go, so assisting is a great way to meet people in the industry while gaining experience. Testing is another useful way to connect with people and it also gives you an opportunity to showcase your styling skills without the added pressure of briefs, budgets and commercial or creative constraints that can come from working with a bigger team on a professional project. Making online contacts also shouldn't be overlooked as many creative teams now first make contact via social media.

Having a network of designers, brands and PRs is also key to the success of a freelance stylist as you will often have to provide clothes at short notice. If you are already trusted by a designer, for instance, they are more likely to lend you pieces as and when you need them. You might meet these contacts at fashion shows, presentations and industry events, or alternatively it's useful for stylists to reach out to designers, brands or PRs they want to build a relationship with via email or social media.

Self-promotion

When you are self-employed, self-promotion is more important than ever and the more ways someone can discover your work the better. A portfolio, website and social media platforms are all important tools in a freelance stylist's toolkit. Not only do they make it easier for potential clients to see your styling but they are also vital when approaching a new brand, editor or company who will want to see examples of your best work.

Being adaptable

A freelance stylist must be adaptable. One day you might be steaming and preparing garments for an e-commerce shoot in a studio and the next you might be hunting down a rare vintage piece for a high fashion editorial. The freelance stylist's role is multifaceted and demands creativity, flexibility and resourcefulness. If you embrace the challenge, freelance styling is a rewarding and fulfilling career option.

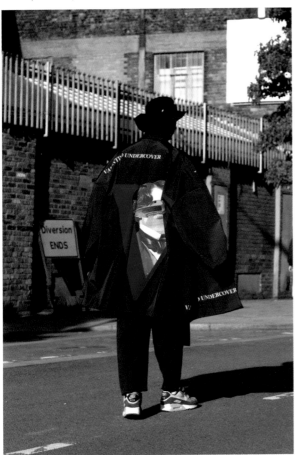

Figure 6.10 **Reaching out to local shops and boutiques to source clothes for test shoots not only gives you access to unique pieces but also opens up a new network of contacts to connect with.** Photography: Tia Millington.

Interview

Aisha Jimoh

Aisha Jimoh is a freelance stylist. She has styled for Harrods, Harvey Nichols, Supreme, *Cosmopolitan* and Channel 4.

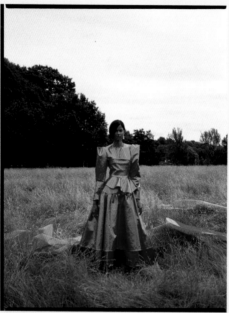

Figure 6.11 **'Million Dollar Babe', an editorial for *F word magazine*.** Photography: Zeinab Batchelor. Styling: Aisha Jimoh.

How did you begin your career as a stylist?

I originally studied economics but I dropped out after nearly three years to study advertising instead. Throughout my time at university – and afterwards – I undertook a series of internships, from assisting stylists to interning at the fashion departments at publications such as British *Vogue* and *Sunday Times Style*.

How would you describe the role of a stylist's assistant?

As an assistant I would handle sample requests and returns, which means I would facilitate borrowing garments from a designer or their PR and ensure their safe return. Additionally, I would often be in charge of replying to emails if we were busy on set and the stylist was unable to do so. Remote assisting was another interesting opportunity to work with a stylist in a different way. A stylist in another country would send me her sample requests for her shoots and I was in charge of making sure they arrived to her in time and coordinating the returns. I have assisted all types of stylists, from commercial and editorial to celebrity stylists. It helped me make connections with lots of different PRs, brands and designers that I wouldn't have been able to in the past, meaning I could reach out to them when I had my own shoots.

Assisting also helped me gain exposure to the industry. I had a very academic background and I wasn't sure how I would achieve my dream of being a stylist so I asked lots of questions to learn as much as possible from the people I was working with.

How do you promote your work? Do you have a portfolio?

I chose to have a digital portfolio because I felt like it was the easiest way to showcase my work without having to spend a large amount on printing for a physical portfolio. I have never been asked for a physical portfolio and nearly everyone has asked for a website or Instagram account when they want to see my work. I've always found it super easy to make customizations to a website and build something that I feel showcases my work well. A digital portfolio has a larger reach and is a far easier way to connect with potential clients who may not live in your city or country.

I also use Instagram as a platform to promote my work because it can have a huge reach. I have been able to connect with a lot of people through it, including photographers, hair stylists, make-up artists, musicians and potential new clients. I always knew that having some sort of digital presence was necessary if you have a creative job. On top of emailing potential clients and networking at events, I thought it would be smart to have another place to upload my work. I update it more than my website. I think it's important for me to show some of my personality. I love showing my personal style – I always get a lot more engagement. I've even been offered work based solely on my Instagram.

What are the benefits of working freelance?

The benefits of working freelance versus working for one company is the freedom to commit to as many projects as possible. I felt like I had to take a big risk to gain a significant reward and going freelance was, for me, the only way I could have done it. It's a great thing to do while you're young and have fewer commitments if you're really serious about pursuing a career in styling. There were times when I've been scared and wanted to go back to a full-time job for more regular money but freelancing was the best choice for me. You have the room to develop your own voice and flex your creative muscles by collaborating with lots of different people. I think that would be difficult to do in a full-time job for a publication or brand.

What advice would you give to someone starting out as a freelance stylist?

Create what you would like to see, not what you think would give you those 200+ likes on social media. Look within for inspiration and seek out advice from as many people who are in the creative industry as possible, it doesn't just have to be stylists. I have received some great advice and jobs from photographers, creative directors, make-up, hair stylists and models.

Securing an agent

Having an agent is similar to being free-lance in that you will have the opportunity to work on a wide range of jobs. However, rather than having to find and pitch for your own work, an agent will do it for you. Your images and details will be listed on the agency's website, and brands, publications and other companies can then reach out to your agent to hire you for a specific shoot or project. In addition, an agent will promote you, sending out your portfolio in order to attract new clients. In return for representing you, the agency will take a percentage of what you earn.

While a freelancer can decide which days they want to work, an agency-represented stylist will generally work according to when the agency assigns them work, although there is some discretion and it is not necessary to accept every job. There may be a little less freedom involved, but having an agent can lead to more regular work, a more secure income and less time spent on self-promotion and admin.

Choosing an agency

There are many different types of agencies to choose from, including boutique agencies, international agencies, fashion-specific, creative and even model agencies which have branched out into other areas. Traditionally an agency for creatives may have just represented stylists, make-up artists, hair stylists and photographers but now many also represent influencers, manicurists, set designers, producers and more, so having other creative skills such as prop styling can be greatly beneficial.

Figure 6.12 An agent helps stylists secure a wide variety of work, from TV adverts to beauty editorials. Photography: Jesse Laitinen. Styling: Masha Mombelli.

Deciding which agency to approach can depend on many things: how experienced you are, whether you are willing to travel or whether you want to specialize in a specific type of styling work, for example editorial, commercial, menswear or womenswear. While a bigger agency might appeal initially, a small agency can be valuable in nurturing your talent and developing your career. The values and ethics of an agent and how well you get on with the bookers can be just as important as how famous the name is.

Approaching an agency

First impressions are crucial, so your initial approach to an agency should be concise and professional. Many agencies have guidelines for getting in touch on their website; these should be followed carefully in order to show you can pay attention to the details. If there are no guidelines, send an email with a brief introduction and attach a CV and a few examples of your work. Alternatively, you could send a link to your professional website. Bear in mind that agencies will be very busy, so it's not unusual for it to take a few weeks to receive a reply. Should you not hear back after two weeks, a polite follow-up email or phone call is the next step to take.

Some agencies may not be adding to their books, while others may be looking

for different skills, so draw up a shortlist and move on if you don't hear back from your first choice. Rejections are inevitable within the creative industries but they're certainly not a reason to give up. Many successful stylists are rejected numerous times throughout their careers before getting a significant career break; resilience is a key strength.

When is the right time?

While some agencies do take on new talent, many prefer to see a well-honed portfolio before offering representation. Rather than rushing to find an agent, it's advisable to gain as much experience as you can by testing and assisting in order to build up a varied, creative portfolio that will attract an agent. This can be achieved while at college or university, on a freelance basis or even on evenings and weekends. The portfolios on an agency website provide a useful benchmark and once you have a body of work to show which is of a similar standard, prepare your portfolio and get in touch.

Alternatively, you may also contact an agency to offer your assisting skills, therefore gaining experience and networking with people who could later offer you agency representation.

Interview

Sam Moore, Director of ME

ME is a creative agency which represents stylists, hair and make-up artists and fashion directors. It has collaborated with brands and publications such as Google, Nike and British _Vogue_.

Figure 6.13 **ME use their website as a platform to promote the creatives they represent.** © ME.

What are you looking for in a stylist when you take them on? What sort of experience would they need?

Although a subjective criteria, we tend to try to spot 'creativity'. This is more of a gut feeling, so a university degree is not necessarily required – but it is one way for prospective stylists to have the ability to shoot and create portfolio work. As an agency, clients come to us for our personal selection of artists. For us this includes everything from their eye for fashion, to more individual character, personality traits and work ethic.

How should a stylist go about contacting agencies?

Like most agencies, we are very busy so the least intrusive way is preferred. An email directing to a portfolio website is the preferred method, with a follow-up call to put a voice to a name. Aesthetically we still all love to see and feel a printed portfolio but in reality an up-to-date website is more usable and – most importantly – easily saved and shared with colleagues.

How does having an agency differ from being freelance?

Being with a good agency will mean the individual will benefit from being part of a larger entity – and the reputation that agency has established. This may offer the artist greater creative collaborations, a higher calibre of clientele and a more professional, long-term approach to work. A good agency will protect an artist's interests as well as offering added value to clients.

How do you organize a stylist's diary?

Like a complex jigsaw, our booking team try to find the most efficient fit of multiple jobs as they come in. They use their years of experience to evaluate the time and resources required for the best fit and maximum volume of work for each artist.

Does a stylist have any say about whom they work with?

We discuss aspirations and career direction with each artist and work together to accomplish those goals, whether that's working towards a specialism of womenswear, menswear or kidswear, or working with a certain brand.

What skill sets does a stylist need?

Due to prep and fittings, the stylist needs to start before most of the rest of the team and usually finishes after everyone else because of packing down and returns, so hard work and unwavering enthusiasm are good core skills. Due to this, and having absorbed the brief for the prep requirement, they often find they are the most informed person on set and can help steer the direction of all aspects of the shoot to fit the brief.

What advice would you give to a stylist seeking representation?

Different agencies may have varying criteria – but we try to discover the perfect blend of creativity, passion, hard work and ethics. Many of those are hard for a prospective stylist to communicate, but producing regular, creative fashion content, having patience and evolving a unique style tends to get noticed – eventually!

Should creatives have separate social media accounts for their creative work or is there a benefit to mixing personal posts with work posts on one account?

Public social media is the fastest way for anyone to investigate and infer (fairly or not) a person's skills and character. Therefore, content profiles created with work in mind should be considered but not lacking in personality.

The future of styling

Trying to determine the future of the fashion industry is challenging; however, as we have illustrated in this book, fashion imagery, in its many guises, is as important as ever. With 95 million images and videos being uploaded to Instagram every single day, the ability to communicate creatively – and visually – is crucial in our tech-driven culture.

How the role is changing

As a response to accelerated consumption and a growing wealth of digital platforms, the role of a stylist is shifting in a more multifaceted direction. Today's stylist has to work more quickly and produce more content, often in less time.

While the first stylists would have simply sourced clothes for either a print editorial or a fashion show, the role quickly expanded. Stylists are often the unsung heroes of a project, credited solely as the stylist despite having made a significantly bigger contribution to the final outcome, from overall concept development to location scouting and casting.

Stylists work so closely with the photographer, both conceptually and physically (standing next to them so they are able to see what the photographer sees), that in some instances, the stylist has greater input into the direction of a shoot than the photographer.

The history of the stylist as a multidisciplinary creative paved the way for the more varied roles we see now. Today's stylist could be tasked with capturing BTS imagery and creating content for print, film and social media but the role has the potential to expand far beyond these boundaries.

The visionary stylist of the future might engage with and shape fashion within new mediums in a more digitized industry. Where once a stylist might have had to consider for the first time how clothes would move in a GIF, now one might have to think about how a viewer interacts with a virtual reality garment.

There will always be different aspects of the job that wildly differ (for instance e-commerce styling and styling for film), and, by being innovative in your research and creativity, you will be able to adapt and respond to an ever-evolving industry.

'I was the one who would often have the idea. I'd become tired of handing over those ideas to photographers who then get the credit.'

Venetia Scott

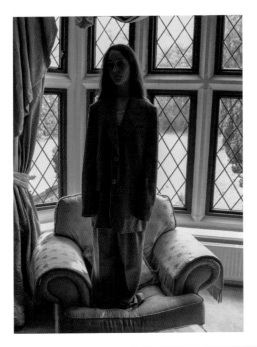
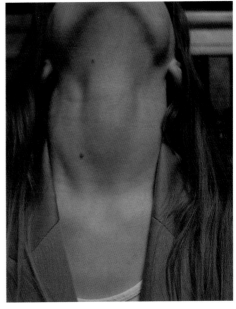

Figure 6.14 **The role of a stylist is quickly changing and now often encapsulates everything from location scout to casting agent and more.** Photography and styling: Lucy Hayes.

The stylist entrepreneur

The many-sided nature of styling promotes an entrepreneurial approach. A stylist now has the ability to create their own opportunities by independently promoting themselves, without needing the approval of the traditional 'gatekeepers' of the industry such as editors and agents. By presenting your work and yourself on a website and using platforms such as Instagram, Pinterest and YouTube, you allow potential clients and collaborators to cut through the professional exterior and see the person. They are not just hiring a portfolio, they are hiring the person.

This convergence of the public and the private self can be part of the modern stylist's remit. For example, you might share BTS shots, your own outfits, outtakes from shoots, found inspiration, memes and your general philosophy. As well as an insight into your creativity, these all offer a reflection of your personality and character.

This new era of sharing has been so influential that agencies and clients now often encourage this kind of content as part of a stylist's contract.

In some instances, the stylist becomes a recognized figure in their own right. In others, being a recognized figure facilitates them then becoming a stylist. For example, an individual who has built up a large audience by sharing their personal style may then be hired to style a campaign.

Curating your own style can be a useful promotional tool; however, it is not a substitute for the foundations of styling described earlier in the book.

'As we enter the conceptual age and the global village grows, it will be the individual (stylist) that stands out who will make the difference.'

Alex White

The industry's ever-evolving landscape is a challenge within itself. Sustainability and ethical considerations, digital innovation and changes in consumer behaviour mean that flexibility, awareness and purpose, an ability to predict, react, regroup and reconsider are essential characteristics for a stylist.

You must be able to interpret the trends and movements and adapt to what's coming next in order to forge a meaningful career.

'The people who survive are genuinely creative and aren't there for the party'.

Penny Martin

Figure 6.15 **Today, a stylist must juggle many different tasks. The stylist's role for this shoot involved casting, sourcing, location scouting, photography and editing.** Photography and styling: Lucy Hayes.

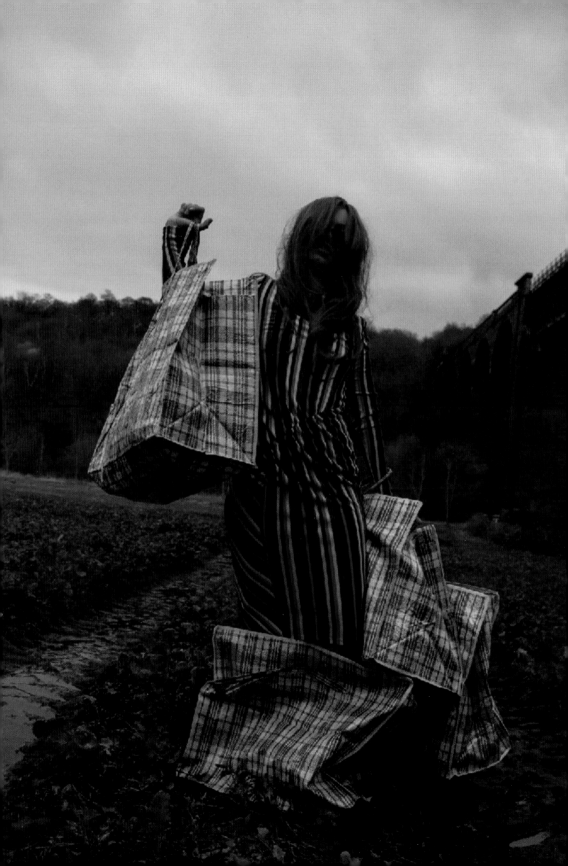

Aoki, Shoichi. *Fruits*. Phaidon Press (2001)

Arnold, Rebecca. *American Look: Fashion and the Image of Women in 1930s and 1940s New York*. I.B.Tauris (2008)

Barnard, Malcolm. *Fashion as Communication*. Routledge (1996)

Baudot, François. *Chanel*. Editions Assouline (2004)

Baxter-Wright, Emma; Clarkson, Karen; Kennedy, Sarah; and Mulvey, Kate. *Vintage Fashion*. Carlton Books (2010)

Berger, John. *Ways of Seeing*. Penguin (1972)

Bolton, Andrew; Cleto, Fabio; Garfinkel, Amanda; and Van Godtsenhove, Karen. *Camp: Notes on Fashion*. Yale University Press (2019)

Calasibetta, Charlotte Mankey; Tortora, Phyllis G; and Abling, Bina. *Fairchild Dictionary of Fashion*. Fairchild Books (2003)

Carter, Graydon; and Foley, Bridget. *Tom Ford: Ten Years*. Thames & Hudson (2004)

Cotton, Charlotte. *Imperfect Beauty: The Making of Contemporary Fashion Photographs*. V&A Publications (2000)

Derrick, Robin; and Muir, Robin. *Unseen Vogue: The Secret History of Fashion Photography*. Little, Brown & Company (2004)

Derrick, Robin; and Muir, Robin. *Vogue Covers: On Fashion's Front Page*. Little, Brown & Company (2009)

Diane, Tracey; and Cassidy, Tom. *Colour Forecasting*. John Wiley & Sons (2005)

Dwight, Eleanor. *Diana Vreeland*. HarperCollins (2002)

Fukai, Akiko; Suoh, Tamami; Iwagami, Miki; Koga, Reiko; and Nie, Rii. *Fashion: A History from the 18th to the 20th Century*. Taschen (2006)

Hack, Jefferson. *Dazed and Confused: Making it Up as We Go Along*. Rizzoli (2011)

Jackson, Tim; and Shaw, David. *The Fashion Handbook*. Routledge (2006)

Jaeger, Anne-Celine. *Fashion Makers Fashion Shapers*. Thames & Hudson (2009)

Jeffrey, Ian. *The Photo Book*. Phaidon (2005)

Jobling, Paul. *Fashion Spreads: Word and Image in Fashion Photography since 1980*. Berg (1999)

Jones, Terry. *Smile i-D: Fashion and Style: The Best from 20 Years of i-D*. Taschen (2001)

Jones, Terry; and Rushton, Susie. *Fashion Now 2*. Taschen (2005)

Keaney, Magdalene. *Fashion and Advertising*. RotoVision (2007)

Koda, Harold. *Extreme Beauty: The Body Transformed*. Yale University Press (2001).

Koda, Harold. *Model as Muse*. Yale University Press (2009)

Lagerfeld, Karl; and Harlech, Amanda. *Visions and a Decision*. Steidl (2007)

Lewis, Shantrelle P. *Dandy Lion: The Black Dandy and Street Style*. Aperture (2017)

Lodi, Hafsa. *Modesty: A Fashion Paradox*. Neem Tree Press (2020)

Mackrell, Alice. *Art and Fashion*. Batsford (2005)

Martin, Penny. *When You're a Boy: Men's fashion styled by Simon Foxton*. Photographers' Gallery (2009)

Martin, Richard; Mackrell, Alice; Rickey, Melanie; and Buttolph, Angela. *The Fashion Book*. Phaidon (2001)

Maxwell, Kim. *Career Diary of a Fashion Stylist: Thirty Days behind the Scenes with a Professional*. Garth Gardner Company (2007)

Morgan, Jamie; and Lorenz, Mitzi. *Buffalo: The Style and Fashion of Ray Petri*. powerHouse Books (2000)

Mower, Sarah. *Stylist: The Interpreters of Fashion*. Rizzoli International Publications (2007)

Müller, Florence. *Art & Fashion*. Thames & Hudson (2000)

Pham, Minh-Ha T. *Asians Wear Clothes on the Internet*. Duke University Press (2015)

Roberts, Michael. *Grace: Thirty Years of Fashion at Vogue*. Steidl Verlag (2002)

Rutter, Bethany. *Plus+*. Ebury Press (2018)

Sargent, Antwuan. *The New Black Vanguard: Photography between Art and Fashion*. Aperture (2019)

Scheips, Charles. *American Fashion: Council of Fashion Designers of America*. Assouline (2007)

Schuman, Scott. *The Sartorialist*. Penguin (2009)

Shinkle, Eugenie. *Fashion as Photograph: Viewing and Reviewing Images of Fashion*. I.B.Tauris (2008)

Siegle, Lucy. *To Die For: Is Fashion Wearing Out the World?* Fourth Estate (2011)

Squiers, Carol; Aletti, Vincent; Garner, Phillippe; and Hartshorn, Willis. *Avedon Fashion 1944–2000*. Harry N. Abrams (2009)

Steele, Valerie. *A Queer History of Fashion: From the Closet to the Catwalk*. Yale University Press (2013)

Thomas, Dana. *Fashionopolis: The Price of Fast Fashion and the Future of Clothes*. Apollo (2019)

Tungate, Mark. *Fashion Brands: Branding Style from Armani to Zara*. Kogan Page (2008)

Walford, Jonathan. *Forties Fashion: From Siren Suits to the New Look*. Thames & Hudson (2008)

Walker, Tim. *Pictures*. teNeues (2008)

Watson, Linda. *Vogue Fashion*. Carlton Books (2008)

Weil, Christa. *It's Vintage, Darling! How to be a Clothes Connoisseur*. Hodder & Stoughton (2006)

White, Constance C. R. *How to Slay: Inspiration from the Queens & Kings of Black Style*. Rizzoli (2018)

Contributor websites

abigail9968.wixsite.com/mysite
aishajimoh.co.uk
alexanderlockett.com
andrewvowlesstudio.com
artistrylondon.com/styling/max-clark
boyostudio.com
caleharrison.com/artists/jay-massacret#1
carolann1969.portfoliobox.net
charlottejones1497.myportfolio.com
contactimke.myportfolio.com
ellenafgeijerstam.com
ezrapatchett.com
helenmcguckin.com
holliebradbury.com
holmesproduction.com
indiaharris.co.uk
instagram.com/8and2
instagram.com/caitlinxaustin
instagram.com/dannywasere
instagram.com/ellafox.studio
instagram.com/heather.smith.designs
instagram.com/jameelaelfaki
instagram.com/jesselaitinen
instagram.com/jjjjess
instagram.com/k.dvi
instagram.com/lucysmarriott
instagram.com/lyn.dzn
instagram.com/marthaiona_
instagram.com/martyw_
instagram.com/_megcarmichael
instagram.com/mia____clark
instagram.com/ourlayeredhome
instagram.com/ryanrogershinks
instagram.com/ryates.photo
instagram.com/simonfoxton
instagram.com/talligator
instagram.com/zoe.v_m
intrepidlondon.com/artists/mattias-karlsson
jointhedotsmr.com
jonasbresnan.com
laurenemma.co.uk
leandaheler.com
lebook.com/sebastienclivaz
luciearmstrong.com
mapltd.com/artist/jamiehawkesworth
marcprovins.com
marcuspalmqvist.com
mashamombelli.co.uk
meganmandeville.com
nemcee.com

paulbui.tv
redesignerr.wixsite.com/website
representedby.me
representedby.me/stylists/anna-latham
rosscooke.com
saraheyre.co.uk
scotttrindle.com
shopchristophershannon.com
siobhan-lyons.com
thecostumedepartment.net
tiamillington.blogspot.com
timwalkerphotography.com
tungwalsh.com
vanessacoyle.com
willdavidson.com
xanthehutchinson.com
yantiwalsh.myportfolio.com
zaramirkin.com
zeinabbatchelor.com

Fashion trade shows

fashiontech.berlin
londonfashionweek.co.uk
moda-uk.co.uk
modeaparis.com
neonyt.messefrankfurt.com
pittimmagine.com
premierevision.com
purelondon.com
seekexhibitions.com
whosnext.com

General websites and blogs

1granary.com
advanced.style
anothermag.com
artsthread.com
azeemamag.com
businessoffashion.com
commonobjective.co
dazeddigital.com
eco-age.com
fashionforgood.com
fashioninfilm.com
fashionista.com
fashionrevolution.org
graduatefashionweek.com
vhypebeast.com

i-d.vice.com
itsnicethat.com
magculture.com
melaninass.com
models.com
nataal.com
nowness.com
pansymag.com
showstudio.com
stackmagazines.com
teenvogue.com
theface.com
thefashionlaw.com
thefuturelaboratory.com
them.us
vfiles.com
wgsn.com

Galleries and museums

Cristóbal Balenciaga Museoa, Geratia, Spain
cristobalbalenciagamuseoa.com
Fashion and Textile Museum, London
ftmlondon.org
Fashion Museum, Bath, UK
fashionmuseum.co.uk
Fashion Space Gallery
fashionspacegallery.com
The Hepworth, Wakefield, UK
hepworthwakefield.org

Jeu de Paume, Paris
jeudepaume.org
Kyoto Costume Institute, Kyoto, Japan
kci.or.jp/en
The Met (The Metropolitan Museum of Art),
 New York
metmuseum.org
Musée des Arts décoratif, Paris
madparis.fr/en
Museo Salvatore Ferragamo, Florence
www.ferragamo.com/museo/en/usa
Museum of Modern Art (MoMA), New York
moma.org
Simone Handbag Museum, Seoul
simonehandbagmuseum.co.kr
Somerset House, London
somersethouse.org.uk
The Photographers' Gallery, UK
thephotographersgallery.org.uk
Tate, London
tate.org.uk
Textil Museet, Borås, Sweden
textilmuseet.se
The Costume Institute at The Met, New York
metmuseum.org/about-the-met/
 curatorial-departments/the-costume-institute
The Museum at FIT, New York
fitnyc.edu/museum
Victoria and Albert Museum (V&A), London
vam.ac.uk

We would like to thank the following for their support and generous contributions:

Max Clark, Laura Holmes, Helen McGuckin, Lucy Charnock, India Rose Harris, Emma Jade Edwards, Tim Walker, Marc Provins, Jacob K, Will Davidson, Christopher Shannon, Andrew Vowles, Sam Moore, Lucie Armstrong, Aisha Jimoh, Ross Cooke, Patrick Waugh, Louise Goldin, Jonas Unger, Masha Mombelli, Xanthe Hutchinson, Zeinab Batchelor, Jamie Hawkesworth, Marcus Palmqvist, Milos Mali, Anton Zemlyanoy, Adrian Mesko, Jonas Bresnan, Graeme Black, Ezra Patchett, Justine Grist, *The Guardian* magazine, *Russh* magazine, Katie Naunton-Morgan, Holly Blake, Ruzenka @ rp represents, Anna Hustler @ M.A.P London, Marsha Vetolskiy, Akila Berjaoui, Cameron Smith, Dave Schofield, Alexander Lockett, Chloe Amer, Emma Jade Parker, Carol Woollam, Siobhan Lyons.

Our appreciation also extends to the students and graduates of BA Fashion at Liverpool John Moores University along with the many stylists, photographers, models and hair and make-up artists who continue to give their valuable input and expertise on styling projects.

Special gratitude goes to Lauren Roberts for her hard work and enthusiasm in compiling this publication.

We would like to offer our sincere thanks to Belinda Campbell, Faith Marsland and Georgia Kennedy for their support and guidance throughout the project. Thank you also to Deborah Maloney and James Tupper for their help during the production process.

Finally, to our families, Henry and Damien Doyle, Sam Forbes-Walker and to our friends; we're so grateful for your encouragement and patience.